LEGENDARY

POTTSTOWN
PENNSYLVANIA

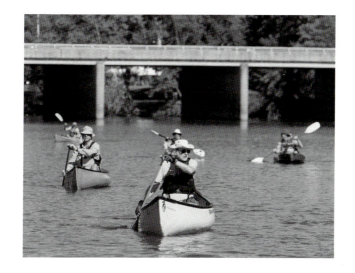

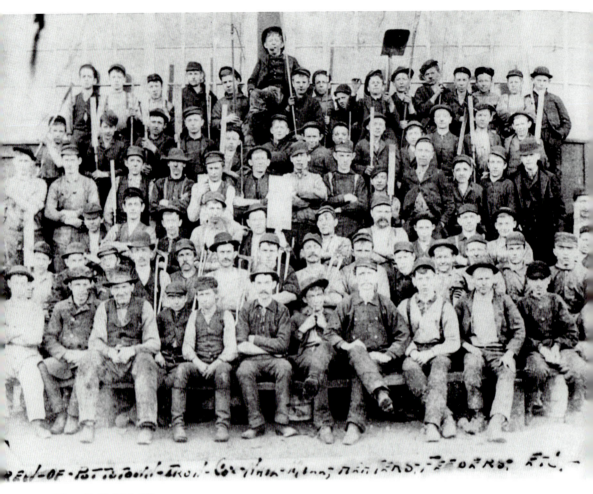

They Built This City
Pottstown's thriving 19th-century economy relied on the hard work and determination of the thousands of men, women, and children who toiled in its foundries, factories, plants, mills, and shops as well as on the railroads. Here is a crew from the Pottstown Iron Company, pictured around 1881. The Pottstown Iron Company was formed in the early 1860s by Morris, Wheeler & Company. Through a series of sales and mergers, it became Cofrode & Saylor, Philadelphia Bridge Works, and McClintic-Marshall Company. Over time, their facilities included a nail factory, rolling mill, blast furnace, and steelworks. It became part of the Bethlehem Steel Company in 1931. Steel from Pottstown's plant built the Golden Gate Bridge in San Francisco and the George Washington Bridge connecting New York and New Jersey, as well as many other notable structures. (Courtesy of Pottstown Historical Society.)

Page 1: Schuylkill River Sojourn, 2008
The first European settlers were drawn to the land that would become Pottstown by the prospect of iron and the flow of water from the Manatawny Creek and the Schuylkill River. During the Industrial Revolution, the river facilitated the transport of raw materials and finished products. In the 1940s, the Schuylkill was the site of the first major environmental cleanup of any river in the United States. Today, the waterway and the Schuylkill River Trail provide habitat for the flora and fauna of the Schuylkill River Heritage Area and recreational opportunities for thousands of residents and visitors each year. Here, paddlers leave Pottstown on the annual seven-day Schuylkill River Sojourn. (Photograph by Cody Goddard.)

LEGENDARY LOCALS
— OF —
POTTSTOWN
PENNSYLVANIA

SUE REPKO AND ED BERGER

Copyright © 2013 by Sue Repko and Ed Berger
ISBN 978-1-4671-0085-4

Legendary Locals is an imprint of Arcadia Publishing
Charleston, South Carolina

Printed in the United States of America

Library of Congress Control Number: 2013930311

For all general information, please contact Arcadia Publishing:
Telephone 843-853-2070
Fax 843-853-0044
E-mail sales@arcadiapublishing.com
For customer service and orders:
Toll-Free 1-888-313-2665

Visit us on the Internet at www.arcadiapublishing.com

Dedication
This book is dedicated to the people of Pottstown—then, now, and in the years to come. May your creative and entrepreneurial spirit, grit, determination, kindness, and humor live on.

On the Front Cover: Clockwise from top left:
Dan Brunish, owner of Brunish's Deli (Photograph by Ed Berger; see page 80), Hildegard Peplau, nursing theorist (Courtesy of the American Nurses Association; see page 102), Dick and Dave Ricketts, professional athletes (Courtesy of Duquesne University Athletics; see page 90), Dr. Karen Stout, president of Montgomery County Community College (Courtesy of Montgomery County Community College; see page 42), William F. Lamb Sr., founder of Lamb's Music House (courtesy of Pottstown Historical Society; see page 63), Chris Longeway and Sam Rhame, owners of the Milkman Lunch Company & Cake Shoppe (Photograph by Ed Berger; see page 83), Jean Schock, owner of Jean's Lingerie (Photograph by Ed Berger; see page 50), John Potts Jr., son of Pottstown's founder and a Tory (Courtesy of Pottstown Historical Society; see page 11), Marc Weitzenkorn, owner of Weitzenkorn's Men's Store (Photograph by Ed Berger; see page 45).

On the Back Cover: From left to right:
Al Grey, jazz trombonist (Photograph by Ed Berger; see page 62), Sue and Bill Krause, "Mr. and Mrs. Pottstown," (Photograph by Ed Berger; see page 116).

CONTENTS

Acknowledgments	6
Introduction	7
CHAPTER ONE Fearless Founders and Intrepid Industrialists	9
CHAPTER TWO Faithful Leaders	19
CHAPTER THREE Educators and Innovators	31
CHAPTER FOUR Titans of Trade	43
CHAPTER FIVE Creators of Art and Culture	61
CHAPTER SIX Culinary Artists	73
CHAPTER SEVEN Sports Standouts	87
CHAPTER EIGHT Health and Wellness Trailblazers	99
CHAPTER NINE Community Builders	107
Index	126

ACKNOWLEDGMENTS

The amateur historian's work relies on the work of others who have recorded accounts of families, communities, and institutions. I owe a huge debt of gratitude to the Pottstown Historical Society, especially to David Kerns, Clara Hoss, and Michael Snyder, for allowing access and taking the time to dig up photographs and share stories about Pottstown's past. I am especially indebted to Paul Chancellor for *A History of Pottstown, Pennsylvania: 1752–1952*. Thanks to the *Mercury* for its monthly history series by Michael T. Snyder, background publications from Nancy March, photographs from John Strickler, as well as countless feature articles by Evan Brandt on the people of Pottstown; these all proved invaluable. Thanks, too, to the following from the places of worship: June Newman, Emmanuel Evangelical Lutheran Church; Sandy Swann, First Methodist Episcopal Church; Sr. Alberta Shawell, Second Baptist Church; Janet Bressler Prince, Congregation Mercy and Truth; Elaine McFadyen and the Reverend Paul J. Xander, Grace Lutheran Church. Many thanks to all of the following for assistance with information and photographs: Jane Alan at the YMCA; Louis Jeffries, archivist at the Hill School, and Lisa Allen, who scanned many documents and images; Lawrence Green, Archives and Special Collections librarian at Brendlinger Library at Montgomery County Community College; Barb Tschantre of the Pottstown Area Artists Guild; Dave Reidenouer of the Tri-County Area Chapter of the Pennsylvania Sports Hall of Fame; Dominic Viscardi; John Armato, whose connections in the community run broad and deep; and John Katch and his treasure trove of Firebirds memorabilia, including *The Forgettables* by Jay Acton, another great book to have. Thanks to my mom and dad, Patricia and Richard Repko, who were sounding boards and sources of historical tidbits. Last but not least, I will be eternally grateful to Erin Vosgien for tracking me down and for her patience and support, and to Ed Berger for putting pictures to the words. Finally, thank you from the bottom of my heart to all the people who took the time to tell me about their lives and work, how they ended up in Pottstown, and what keeps them here. You are all an inspiration.

INTRODUCTION

I was first contacted in the summer of 2012 by Erin Vosgien of Arcadia Publishing when she came across my blog, *Positively Pottstown*, and wondered if I might be interested in doing a book in their new Legendary Locals series. I did not really consider myself even an amateur historian, but her description allowed a wide berth: "The new imprint celebrates people who have made a memorable impact on their community throughout its history . . . Individuals featured in the books will run the gamut . . . Their images and stories will document the unique contributions residents have made that shape the community today." She assured me that this series featured people who were active in a community today.

So, who could be considered "legendary?" This was the first challenge. Then, who could be considered to be making a "unique contribution?" Executive directors? Chief executive officers? Sure, but there were also plenty of unsung heroes—those who volunteer, or teach, or preach, or paint, or labor on the night shift. What about those thousands of people who arrived here from the other side of the ocean and toiled in backbreaking, dangerous industries to give Pottstown its hard-won reputation as a place to work, buy a home, raise a family, and make a better life?

I began to see the project as way to illuminate the themes that have run through our collective narrative ever since John Potts and the other iron-making families invested here and started an industrial juggernaut that would contribute so mightily to the development of the rest of the nation. Those themes—of the value of hard work and risk taking; of family, faith, and a solid education; of kindness and compassion; of good medical care; of exercise, art, and music—echo in the stories we tell today. And so I chose to go with a concept of "legendary" that would serve the purpose of telling a larger story: the history of Pottstown, from the beginning to the present day, through the faces and stories of its people across all sectors of community life. I found inspiration in Paul Chancellor's *A History of Pottstown, 1752–1952*. (Every Pottstown home and classroom should have a copy.) Chancellor has chapters for all facets of Pottstown life, and I decided I would roughly follow suit.

With the matter of a "legendary local" hardly settled—I would know one when I saw one—it became apparent that there were way too many legends, living and deceased. Pottstown is more than 260 years old, but this book could only be 128 pages long. I started off with a fairly long list of folks to include, and during the course of my research, one thing would lead to another, and I would go hunting down more possible legends. I want to thank all the people who directed me down these paths and let me into their homes and places of business to hear their stories and see and use their photographs. I also got lots of help from the experienced historians, archivists, and keepers of organizational history listed in the acknowledgments section. David Kerns and Clara Hoss were instrumental in pointing the way through the resources at the Pottstown Historical Society. I literally could not have gotten past the first page without them. As the months ticked by, there was so much to uncover, and for each legend, there was not only a story to be learned, there was also an image to be had.

I never doubted for a second my instinct to ask jazz writer and photographer Ed Berger to work on this project. I have known Ed for about three decades; he is my brother-in-law and friend. He is also a whiz at restoration and was able to get the historical and other images into good shape for publication. In his own photographs, he has a way of capturing a look in the eye or a quirk to a smile that sheds more light on a subject. Ed came to town and clicked away while I whisked him from one appointment to the next, all while keeping his sense of humor. I am pretty sure he could walk down High Street now, and someone would call out, "Hi, Ed!" This book was a team effort, and I am grateful to have had Ed on my team.

While I was in the thick of it, and even when I was supposedly nearing the end, there were some days when I did not see how I would ever finish. There was always one more interview and one more caption to write. Then, I met with Dominic Viscardi. I had known Mr. Viscardi since I was a kid; his youngest daughter, Vicky, and I went through St. Aloysius and St. Pius X together. What I had not remembered was that he had worked at the Shuler House. I had wanted to feature someone who had worked at that iconic downtown business before the wrecking ball took it away in 1975. So I went to Mr. Viscardi's house and sat with him at his kitchen table, typing furiously as he got to reminiscing. He showed me some copies of *Pottstown on Parade*, which was "Pottstown's Own Pictorial Magazine Since 1940 Featuring People You Know And Places To Go." It was put out for decades by J. Paul Jones, who went around town taking pictures of people at public events or their places of business just to highlight the life of the community, not unlike Legendary Locals. It felt like things were coming full circle. I was not there too long before Mr. Viscardi said, "You're never gonna guess what else I found." He pulled an eight-by-ten color photograph out of a manila envelope and slid it in front of me. "Do you know who that is?"

I saw a younger Mr. Viscardi standing next to someone looking like an Eastern European peasant woman. I felt a chill run along my arms. No, it could not be. Months ago, when I had stopped in on a bunch of Virginia Avenue friends from the old days during their weekly visit to the hair salon and told them about the book, one of them, Dennis Braunsberg, had asked, "Are you going to include Mary Pennypacker?" and went on to tell some stories about her. My memory could conjure up only the dimmest of images then, but now, here she was again. That incredible photograph is on page 113. The stories about Mary reminded me that there have always been those among us who struggled and needed our compassion. That is also when I realized that I came not only from a family of storytellers but from a town of storytellers. I went back to Mr. Viscardi's the next day to scan photographs, and he insisted on making me lunch—grilled ham and cheese, a bunch of grapes, and a mini-packet of dark chocolate peanut butter Kandy Kakes (my favorite). And I ate every bite, even though I do not usually eat meat, because I had been transported back to a time when that is exactly what I did eat for lunch. It was then I knew that while I would, in fact, finish this book, the people of Pottstown would continue writing the next chapter, and the stories would never end.

—Sue Repko

CHAPTER ONE

Fearless Founders and Intrepid Industrialists

While the pages of any history of Pottstown will necessarily be filled with the contributions of the founding Potts family, there were Native Americans in the area long before the arrival of any Colonial settlers. The Lenni Lenape tribe occupied the area around the Manatawny Creek, whose name meant "the place where we drink." The flowing waters of the Manatawny and of the Schuylkill River would prove instrumental in the burgeoning iron interests of the Potts family.

In 1751, John Potts purchased nearly 1,000 acres from Samuel McCall, whose own father had been granted the land from William Penn's son, in order to build an impressive manor home in the early Georgian style for his expanding family. This home and the area around it were called Pottsgrove (Pottstown would officially become a borough in 1815). While John Potts was already engaged in the iron business, he could not have known that he would be setting the stage for the growth of a regional manufacturing center over the next 200 years.

From nails and bicycles to smokestacks and airplane engines, the contributions of a wide array of entrepreneurs and laborers to a fledgling national economy are truly staggering for such a small town. Perhaps the very reason so many businessmen—and they were virtually all men at first—found Pottstown hospitable to manufacturing was the foundation laid by the Potts family.

The Pottstown area was the Colonial birthplace of the iron and steel industries in Pennsylvania and, hence, in the nation. As construction technologies became more sophisticated to take advantage of these new materials, manufacturers were constantly inventing and innovating to bring the world products that were stronger, better, and faster. Nowhere was the breakneck speed of the Industrial Revolution more evident than in manufacturing centers like Pottstown.

Along with the hard manual labor undertaken in the mills, foundries, and steel and fabrication plants around town, there were other entrepreneurs running hotels, restaurants, and additional service enterprises to accommodate traveling businessmen and visitors from the countryside who could find dining, shopping, and entertainment without having to go all the way to Philadelphia. With the arrival of the Philadelphia & Reading Railroad in the middle of the 19th century and the subsequent waves of immigrants in the late 19th and early 20th centuries, Pottstown's employment and economic growth paralleled the unfolding of the American dream for so many newly arrived on the nation's shores.

Founding Family

John Potts was born in 1710 in Germantown, Pennsylvania, the first-born son of Thomas and Martha (Keurlis) Potts. Shortly after Martha's death in 1716, Thomas married Magdalen Robeson and moved his young family to the Manatawny lands, a vast outpost about 40 miles west of Philadelphia, where the early pioneer Thomas Rutter had already discovered iron ore and established a forge on the Manatawny Creek. Around this time, Samuel Nutt made his way from Philadelphia to Chester County and did the same on the French Creek. These three men—Potts, Rutter, and Nutt—were the fathers of Pennsylvania's iron and steel industries.

Thomas Potts saw to it that his children were well educated in Philadelphia, and through his business acumen and the intermarriage of his children to members of the other iron families, he ensured his family's economic dominance in Pennsylvania throughout the 18th century. Upon Thomas's death in 1752, John Potts became the head of the family. He was already married to Ruth Savage Potts, a granddaughter of Thomas Rutter, and they ended up having 13 children. In 1752, he began building a grand country manor home for his expanding family, just west of the Manatawny, along what was known as the Great Road.

This home and the surrounding land were first called Pottsgrove; the area around it would later be laid out as Pottstown. According to a prior history, Potts laid out High Street where it is now, 100 feet wide. The town's boundaries were the Schuylkill River to the south, Beech Street to the north, Charlotte Street to the east, and York Street to the west. The naming of Penn Street gave a nod to William Penn, who originally purchased the land around the Manatawny from the Lenni Lenape and gave 14,000 acres of it, called "Johnny's land," to his son before it was broken up and sold to various investors.

Most of the male offspring of John and Ruth Potts made significant contributions to the new republic. Thomas Potts was a member of the Convention assembled at the state house in Philadelphia on July 9, 1776, to form a new government. Samuel Potts's Warwick Furnace provided ordnance for the Continental Army. Dr. Jonathan Potts was appointed deputy director general of the military hospitals in the Northern Department by Congress in 1777.

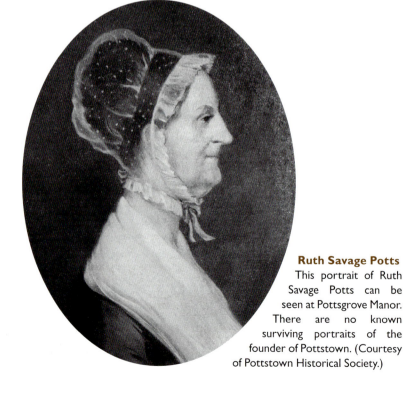

Ruth Savage Potts
This portrait of Ruth Savage Potts can be seen at Pottsgrove Manor. There are no known surviving portraits of the founder of Pottstown. (Courtesy of Pottstown Historical Society.)

CHAPTER ONE: FEARLESS FOUNDERS AND INTREPID INDUSTRIALISTS

A Tory among Them
The most infamous of the Potts sons was John Potts Jr. He was a lawyer, trained in England and the colonies. At the start of the war, he was a judge in the Common Pleas Court. He remained loyal to the Tories, however, and was reportedly in his home at the southeast corner of High and Hanover Streets when it was surrounded by Continental troops. He escaped to Nova Scotia. (Courtesy of Pottstown Historical Society.)

A President from Pottstown
Maj. Gen. Arthur St. Clair acquired the former John Potts Jr. home at High and Hanover Streets. The original building no longer stands, but the current building is marked by a plaque. While a resident of Pottsgrove, St. Clair served in the highest office in the young nation—that of president of the United States in Congress Assembled (USCA)—from 1785 to 1787. The USCA had previously been known as the Continental Congress. (Courtesy of Pottstown Historical Society.)

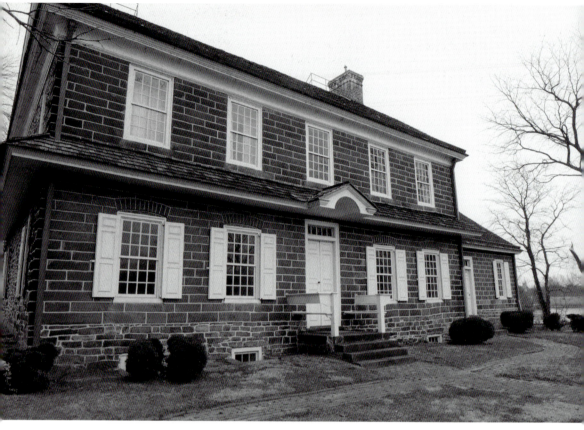

Pottsgrove Manor
Pottsgrove Manor was built between 1752 and 1754, employing the finest artisans and materials for the seasoned-pine floors, marble mantelpieces, brick chimneys and ovens, and wrought-iron locks and hinges. Its two-foot-thick walls were constructed of fieldstone and sandstone. It has been said that George and Martha Washington visited Pottsgrove during the cruel winter of 1777–1778 at Valley Forge, but historians at Pottsgrove Manor have found no evidence to support that. After changing hands several times and falling into disrepair, the home was restored during the 1940s, largely under the direction of architect G. Edwin Brumbaugh, with grants from the federal Works Progress Administration. Pottsgrove Manor still stands today at 100 West King Street and is owned and operated by Montgomery County. Many of the period furnishings are on loan from the Pottstown Historical Society. (Photograph by Ed Berger.)

Marjorie Potts Wendell, 1894–1996

A direct descendant of John Potts, Marjorie Potts Wendell (right) took a keen interest in the preservation of Pottsgrove Manor. She was married to James I. Wendell, who was the headmaster of the Hill School for 24 years, from 1928 to 1952. Thanks to her organizational and fundraising efforts, the Pottstown Historical Society purchased the property in 1939. She is shown here with architect G. Edwin Brumbaugh. (Courtesy of Pottstown Historical Society.)

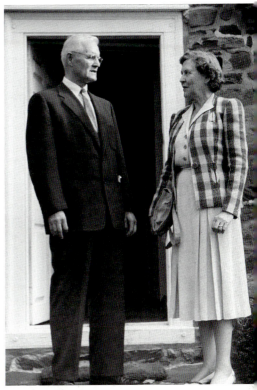

Town and Gown Relations

For many years, there was a distinct intertwining of Pottstown's founding family and the Hill School, the prestigious, private preparatory school founded in 1851 at the east end of High Street. At one point, three Potts sisters, all daughters of Leonard Harlan Potts, were married to three faculty members of the school. The three Potts sisters are, from left to right, Marjorie Potts Wendell, Betty Saunders, and Dozie Colbath. (Courtesy of the Hill School.)

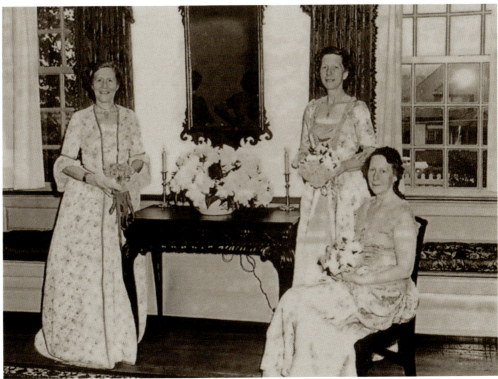

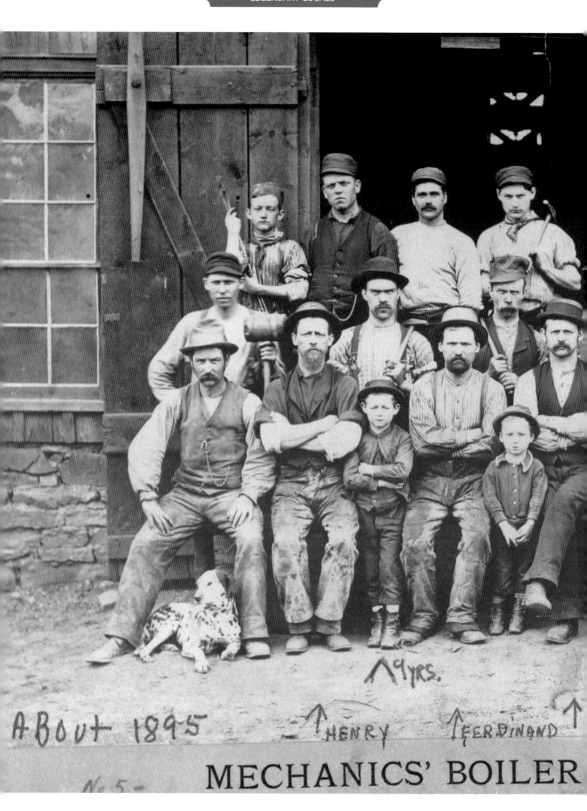

CHAPTER ONE: FEARLESS FOUNDERS AND INTREPID INDUSTRIALISTS

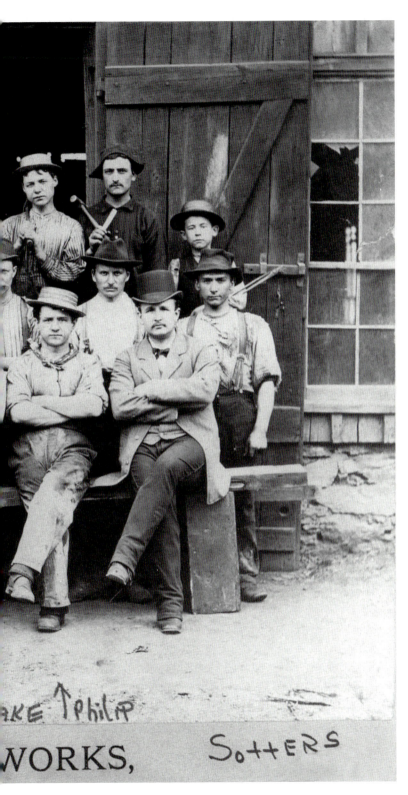

All in the Family
The Mechanics Boiler Works was founded in 1879 and run by four brothers—Jacob, Ferdinand, Henry, and Philip Sotter—all skilled mechanics. Better known as Sotter Brothers, they manufactured boilers, smokestacks, blast and steam pipes, iron stock cars, and water and oil tanks, among other products. At first, they leased a building on the north side of Beech Street, just east of York. Around 1883, they employed 30 people, with a monthly payroll of $1,500. The value of finished work that year was about $60,000. By 1886, they built a larger plant on West High Street between the railroad tracks and the river. (Courtesy of Pottstown Historical Society.)

15

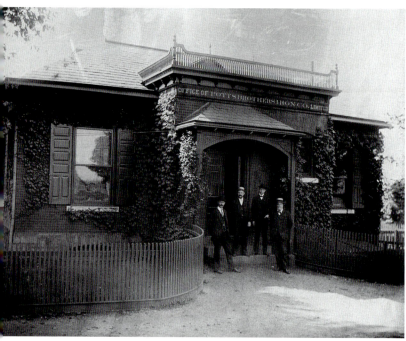

Legacy of Steel
In 1846, the sixth generation of Potts men—Henry and David Potts Jr.— formed the Potts Brothers Iron Company, Limited. Their Pottsgrove Iron Works was located on Water Street between Charlotte and Penn Streets. The men in this photograph are believed to be officers of the company, not to be confused with the Pottstown Iron Company, which eventually became part of Bethlehem Steel. (Courtesy of Pottstown Historical Society.)

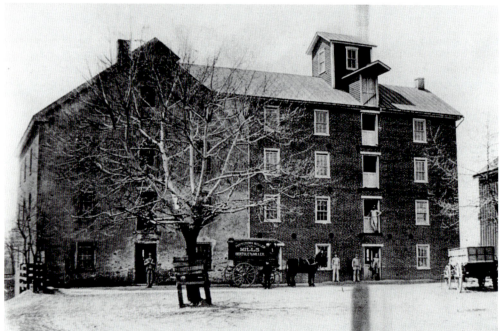

Pottstown's Most Venerable Citizen
Henry and Jacob Gabel ran the former Pottstown Roller Mills at Hanover and South Streets from 1856 to 1867 under the name H & J Gabel. Built in 1725, the structure is in the National Register of Historic Places. A 1901 obituary calls Henry "Pottstown's most venerable citizen" and notes that "he was frequently in a position to take advantage of those reduced in circumstance but he preferred to extend a helping hand to them instead." (Courtesy of Pottstown Historical Society.)

CHAPTER ONE: FEARLESS FOUNDERS AND INTREPID INDUSTRIALISTS

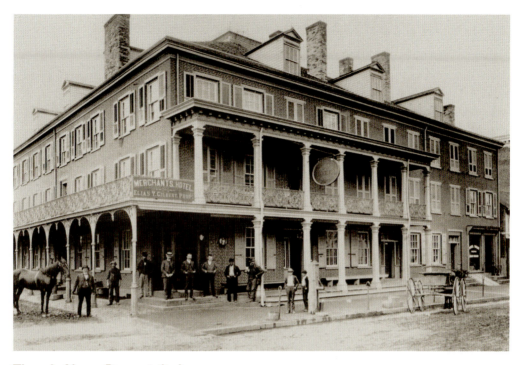

There Is Always Room at the Inn
Elias Y. Gilbert was born in 1824 in Gilbertsville, which was named after his ancestors. After learning his father's blacksmithing trade, he worked in the hotel industry for 40 years, spending much of that time running the Merchants Hotel in Pottstown. A 1903 news article claimed, "In all these years it has been recognized as one of the leading hotels in the Schuylkill Valley." Gilbert is believed to be the man next to the horse in this photograph. (Courtesy of Pottstown Historical Society.)

Cruising Ahead of the Competition
In 1893, Edward S. Fretz was a cofounder of Light Cycle Company, a bicycle manufacturer. When the automobile became more popular than the bicycle in the early 1900s, Fretz had the firm switch to the manufacture of aluminum casings for differential gears and changed its name to Light Manufacturing & Foundry Company. They ended up producing aluminum, brass, and bronze castings; automotive parts; and die castings for automobiles and airplanes. (Courtesy of Pottstown Historical Society.)

17

The Flying Merkel

In 1909, Light Manufacturing bought the Milwaukee company that made the Flying Merkel, a motorcycle used by championship racers. The company's slogan was, "All roads are smooth to the Flying Merkel." With the purchase, all operations were moved to Pottstown, where the Merkel Light was also produced. Sadly, the stock market crash of 1929 put Light Manufacturing out of business. (Courtesy of Pottstown Historical Society.)

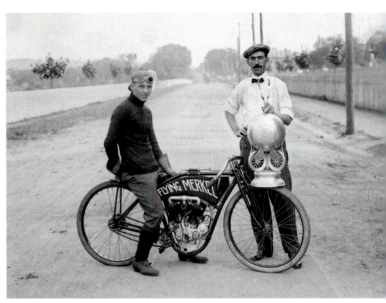

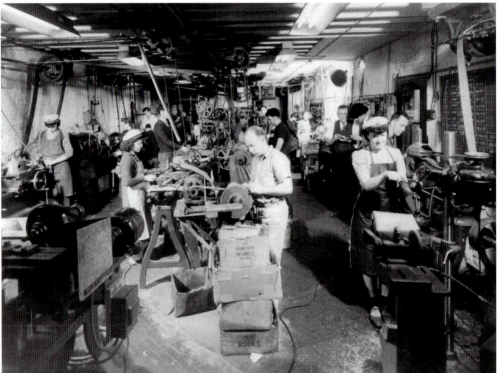

Men and Women of Pottstown Help War Effort

In 1929, the Jacobs Aircraft Engine Company began in Philadelphia, then bought out the defunct machine shop of Light Manufacturing in 1932 and moved its operation to Pottstown. When the company introduced the 225-horsepower L-4 engine in 1934, it was the most efficient in its power class. Throughout the 1930s and through World War II, Jacobs Aircraft created and improved its products, garnering numerous military contracts. (Courtesy of Pottstown Historical Society.)

CHAPTER TWO

Faithful Leaders

The desire to worship according to one's conscience drove the colonists to swiftly establish their own churches, and the early settlers of Pottstown were no different. Since 1796, the Old Brick Church at the corner of Chestnut and Hanover Streets has stood on land granted by the Potts family for the building of a church. Then, as the population grew and the variety of denominations and native languages increased, the churches multiplied throughout the town to accommodate these distinct religious and immigrant communities and help them mark holidays, births, confirmations, marriages, and deaths. Ironically, given that the Society of Friends had constructed the first house of worship in Pottstown, there were never very many Quakers, and a Friends Meeting did not survive—let alone thrive—like many of the denominations still in existence today.

For some churches, the majority of their parishioners now live outside of Pottstown. In some cases, churches are sharing their space with those of other faiths. Yet, even in the modern era, there is no way to cover here the breadth of Pottstown's religious communities. What follows are snapshots of pastors ministering to the people of Pottstown and the surrounding area throughout its history, as well as images and vignettes of the spiritual milestones and social, artistic, and recreational activities that so many of these congregations provided or still provide. For many people, a congregation is an extended family that shares in life's ups and downs, through sickness and health.

Members support not only one another but also those from the larger community who are in need—"the least among us." Several Pottstown churches participate in the Ministries at Main Street homeless shelter program. This involves providing nighttime shelter for a month at a time during the cold weather months to anywhere between 20 and 40 homeless persons from the area. Parishioners provide food and companionship to those showing up for dinner and shelter on those nights. There is also the Pottstown Cluster of Religious Communities, an interfaith consortium that provides food, clothing, services, and referrals to individuals and families going through a rough patch on the road to self-sufficiency. In the course of these charitable efforts, the empathy of the people of Pottstown comes through along with the proof of their understanding of the saying, "There but for the grace of God, go I."

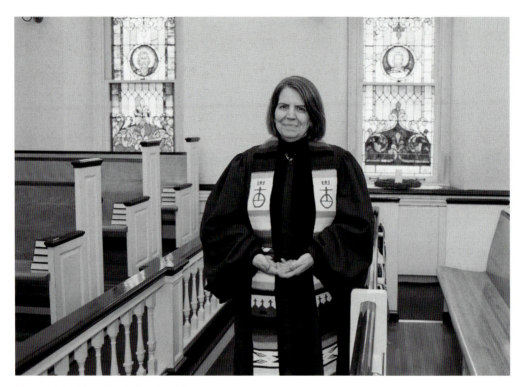

The Little Church with a Big Heart

Zion's United Church of Christ at 209 Chestnut Street is set in the heart of one of Pottstown's two historic districts. Known as the "Old Brick Church" and the "Little Church with a Big Heart," it has been at its original location since 1796. According to Rev. Linda Higgins, the current (and first female) pastor, "So many of the local UCC and Lutheran churches broke off from here, depending on the issue of the moment."

Higgins received her bachelor of arts degree from Lafayette College and her master of divinity degree from Yale Divinity School. She began her ministry in Easton, Pennsylvania, in 1983 and has held ministerial positions in New York, New Jersey, and Connecticut. She has also worked as a teacher, Christian educator, social worker, and counselor, in addition to raising three children.

Although Higgins is new to Pottstown—she began her ministry here in November, 2011—she has an enthusiasm and instinctive understanding of the community. "I love Pottstown," she said. "We all know we're on a cusp, and the church is very good about reaching out into the community." Hers is one of the churches participating in the Main Street homeless shelter program. They also host a weekly game night, during which their congregants play board games with those in need. Their website says, "We are a church of friendship, warmth, and nurture—a place where everybody knows your name. All visitors are welcome."

On any given Sunday, there might be between 85 and 100 parishioners in attendance. "We're somewhat limited in people power," said Higgins. "But most have been members for decades and their families have been here for generations."

For the past six years, Higgins has studied and practiced to become a Reiki master. Reiki is a spiritual practice that incorporates energy therapy and can be used in many different situations for healing. Higgins was quick to note the historical laying on of hands as a way to engage in healing prayer and to emphasize that Reiki is a discipline that can deepen one's faith, no matter what faith that is. Reiki can provide the language for those who consider themselves spiritual but not necessarily religious. "I use it bedside. I use it to prepare the space before worship," she said. "For me, it's a way I do my discipline, but I will also help someone who has a sore shoulder." (Photograph by Ed Berger.)

CHAPTER TWO: FAITHFUL LEADERS

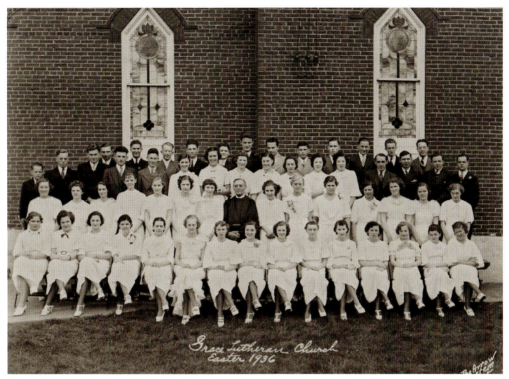

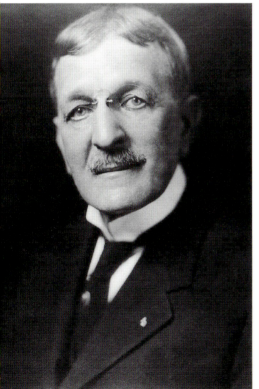

Expanding the Flock
The Reverend J.J. Kline was the founding pastor of Grace Lutheran from 1897 to 1937. He is shown here with the confirmation class of Easter 1936, perhaps his final one. Under his leadership, the congregation grew from 62 charter members to 475 communing members. The building behind the group is the original church on the southwest corner of West and Evans Streets. Today, Grace Lutheran is located at 660 North Charlotte Street. (Courtesy of Pottstown Historical Society.)

Genteel and Gracious
The Reverend William H. Lindemuth was the beloved pastor of the First Methodist Episcopal Church in 1897, at the end of an era when pastors served only one to two years, and from 1935 to 1939. Congregant Alice Seidts recalled, "In 1938, I was to be confirmed, but I had pneumonia. Reverend and Mrs. Lindemuth came to my house, sat next to me on the sofa, and told me what I needed to know. He was a comforting man, and his wife an extremely gracious lady." (Courtesy of Pottstown Historical Society.)

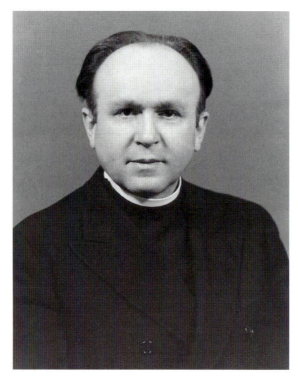

"Faithful And Venerate Servant of God"

On May 3, 1967, Emmanuel Evangelical Lutheran Church held a testimonial dinner to honor the Reverend Luther A. Krouse. Reverend Krouse was in poor health, and the event marked his retirement just days earlier after 35 years of service in Pottstown. The program booklet created for the dinner provided some details of Krouse's life.

He was born in Reading in 1897 and was valedictorian of his class at Reading High School for Boys. He attended Muhlenberg College until World War I interrupted his education. After returning from naval service, he crammed his senior-year studies into just four months. He was then named valedictorian of his college class of 1919. By June 1922, with his degree from the Lutheran Theological Seminary of Philadelphia in hand, he was ready to accept his first calling in Ridgway, Pennsylvania, and be ordained.

On June 18, 1924, he and Grace Mary Yocom of his home parish in Reading were married. They had two sons—L. Samuel, who also became a Lutheran pastor, and David, who died suddenly at 13.

While serving in a parish out near Pittsburgh, Krouse received the call to Emmanuel in 1931. After much prayer, the family came to Pottstown in January 1932, and Krouse began his long tenure of service. During his ministry, he presided over 636 weddings, 1,429 funerals, 1,701 baptisms, and 1,682 confirmations. He initiated "some unique and stimulating programs" in the church and Sunday school. One such program, the Penny-A-Meal project, was intended to reduce the church's debt during the Depression by having each family member put a penny into a wooden church that was placed on their table at home at mealtimes. On the first Sunday of each month, the families turned in their pennies.

Krouse also ensured the church auditorium was filled to capacity during spectacular Easter, Christmas, and Reformation pageants: "He also created the Living Pictures that became a popular medium for illustrating hymns, Bible stories, and events in Christian history. Costumed persons posed inside a giant picture frame while a soloist or narrator related the scene so portrayed."

On the night of the testimonial dinner, the menu included fruit cocktail deluxe, hearts of lettuce with Russian dressing, spiced applesauce, prime pot roast of beef with mushroom dressing, Pennsylvania Dutch potato filling, golden corn, lima beans, ice-cream soufflés, and fancy cookies, all served by Hartenstine's Catering Service. (Courtesy of Pottstown Historical Society.)

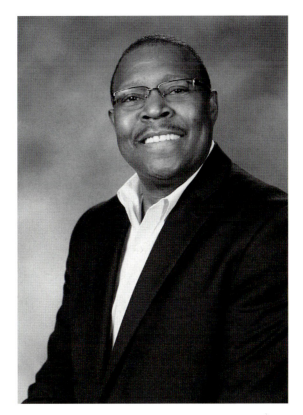

Leading a Community Church

The Reverend Dr. Vernon Ross went to the Lutheran Theological Seminary of Philadelphia thinking he would become an assistant pastor, but when the pastor at Bethel African Methodist Episcopal (AME) Church at 401 Beech Street in Pottstown became ill, the bishop asked him to fill in for three months. That turned into 12 years.

Ross has also been employed by Lockheed Martin for the past 22 years. "It gives me balance," he said. "Lockheed Martin has been most gracious in managing my schedule." Currently, he is the corporate staffing director, managing the placement of employees, and hiring future talent to replace those who are retiring. His job is to make sure they have the right talent at the right time and in the right business to support the company's objectives and growth. He describes himself as "bi-vocational."

"There's a lot of what I do and teach at Lockheed that I use within the confines of the church. I'm at the church on Sundays, on the weekends, and some evenings during the week, too." When he arrived at Bethel AME, there were only 14 members. He attributed the decline to a combination of factors. Many members had moved out of the area. Some had gone back to the south, where their families were from. Quite a few had passed away, and some of the younger people did not return after going away to college. Now, though, there are more than 300 members, and they are in the midst of a capital campaign to build a new church at the corner of Lincoln and Grant Streets. Some of the new members are driving from as far away as Blue Bell, Norristown, and King of Prussia. Ross attributes the growth to "a very strong music ministry, several food programs, and a strong youth ministry. We really involve our youth, and we have established a scholarship fund to ensure our kids are going to college."

As of the spring of 2012, Bethel AME had raised more than $200,000, purchased land, done demolition, and had an architect's sketch in preparation for the new church. The entire project is estimated to cost $1.4 million. "We are a community church that will provide greater programming for the community. It's really exciting to see the church full on Sunday mornings and the group engaged about being part of the community." (Courtesy of Vernon Ross.)

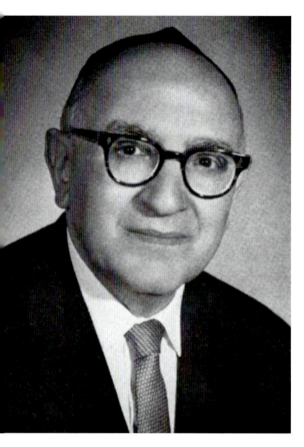

Like Father . . .

Dr. Emil Schorsch came to Congregation Mercy and Truth in 1940 after having served 12 years as rabbi in Hannover, Germany. Schorsch led the congregation through the move from High and Warren Streets to North Keim Street 51 years ago, writing, "A new Synagogue does not only call for a larger attendance at worship and study, but for people who realize its vital role for the survival of a humane civilization." (Courtesy of Congregation Mercy and Truth.)

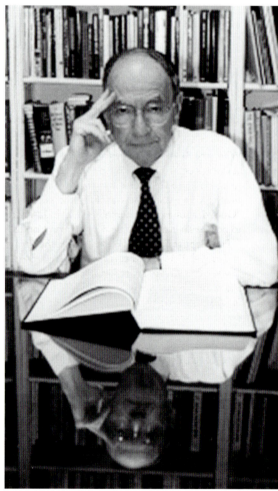

Like Son

Dr. Ismar Schorsch, son of Emil Schorsch, is chancellor emeritus of the Jewish Theological Seminary (JTS) and Rabbi Herman Abramovitz professor of Jewish history. He retired in 2006 after serving 20 years as chancellor and advancing his commitment to Conservative Judaism. Now he has returned to the work he loves: serious scholarship. Schorsch graduated from Ursinus College and was ordained by JTS in 1962. He and his wife, Sally, have three children and 11 grandchildren. (Courtesy of the Jewish Theological Seminary of America.)

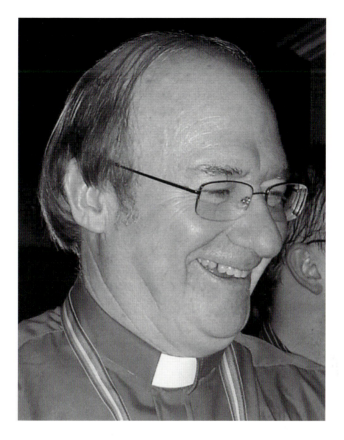

Being Marvin

When the Reverend Dr. Marvin Marsh was laid off from a denominational staff position at the end of 1995 at the age of 50, he negotiated a secular outplacement during the severance process. He ended up helping to open Neiman Marcus at King of Prussia and selling silver, china, and crystal through much of 1996. It was then that he realized he was doing the same thing as always: relating to people in a caring, spiritual way. "Our vocation is to be ourselves," he said. "My career is to be Marvin, and I realized I had more freedom to be Marvin in a church than at Neiman Marcus."

First Baptist Church of Pottstown, at the corner of King and Charlotte Streets, was looking for a pastor in October 1996, and that is when Marsh arrived. "I did not come here to change a blessed thing," he said. "I was 50. I needed a job. I had no agenda." But he was determined to stay true to his own convictions. His prior job had been as director of the Neighborhood Action Program with the National Ministries for American Baptist Churches, working in impoverished communities. "I was attracted to situations of creative desperation," he said.

At First Baptist in Pottstown, parishioners have moved in the direction of inclusivity along the lines of class, race, and sexual orientation, which are passionate issues for Marsh, who says he was on a path to be a pastor since he was ten. While his parents flew to Texas to a clinic as a "last ditch effort" in his father's two-year battle with cancer, his uncle had driven him and his brother to Kansas to stay with family. They were all reunited in Kansas, expecting to drive back to Illinois together, but his father passed away before the return trip. When Marsh's mother called home to say what had happened, Dr. Pratt, their pastor, said, "I'll see you tomorrow." He was a pastor of a 1,000-member church, but he traveled 400 miles to be there the next day. He stayed with Marvin's family and conducted the funeral. It was a transformative experience for Marsh, who said, "Although I couldn't articulate it as a youngster, I knew later that the number one piece is just being there. Being present. My second lesson from a variety of experiences in the years to follow is that: we're all more alike than we are different." (Courtesy of Marvin Marsh.)

Growing in Faith

Founded in 1895, the Second Baptist Church grew rapidly with the arrival in 1938 of the Reverend Heywood L. Butler, shown here with the 1940 choir. During Butler's tenure, which lasted until his death in 1971, the church ran a diner and store and acquired land for a cemetery in Douglassville and land for a new church at the corner of North Adams Street and Jefferson Avenue. The church was built between 1966 and 1974, as donations came in. Butler was also chaplain of the Pottstown Firebirds. In the photograph are, from left to right, (first row) Ella Scott, Esther Jackson, Lucy Grey, Frances Green, Lillian Prince, Beatrice White, Amy Strawther, and Jennie Thornton; (second row) Richard Thornton, Thomas Carter, Charlie White, Rev. Heywood L. Butler, Wade Foster, Willis Strawther, William Malone. (Courtesy of Pottstown Historical Society.)

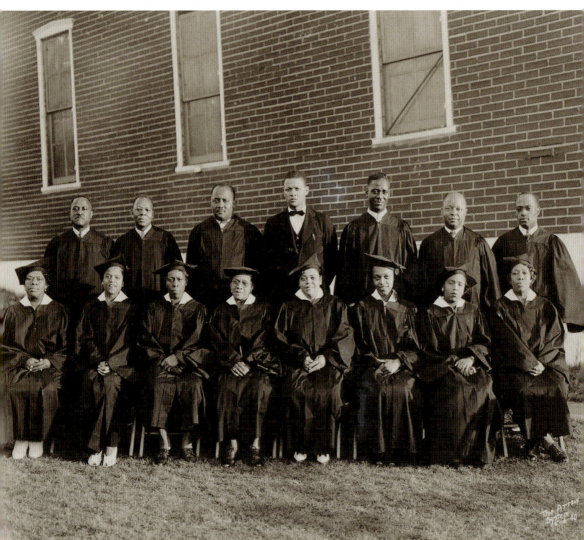

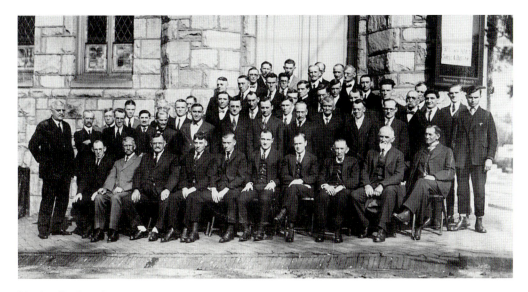

Methodist Leader
According to Chancellor's *A History of Pottstown, Pennsylvania*, Searles Memorial Methodist Church at Hanover and Beech Streets grew out of a Sunday school of devout Methodists in Glasgow Village. In 1889, the group located to Fifth and York Streets. The stone church that stands today was dedicated in 1909 and named after Thomas Searles, a prominent member and president of the board of trustees. This image of the men's Bible study group is likely from that era. (Courtesy of Pottstown Historical Society).

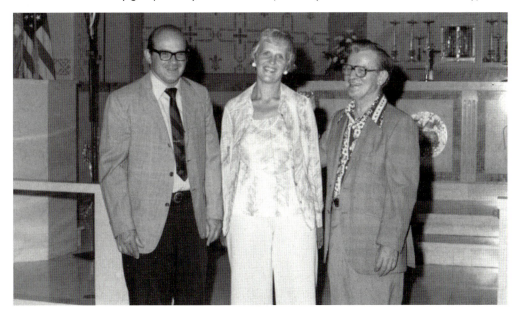

A Half-Century of Hymns
Eleanor Kurtz served as the St. Aloysius organist for approximately 50 years. She is shown here with tenor Richard Repko (left), who has been in the St. Aloysius choir, off and on, since 1948. He also sang with the First Presbyterian choir for 10 years and the St. Columbkill choir in Bally for 10 years. Frank Powell (right) sang tenor and was choir manager at St. Aloysius for many years. (Courtesy of Patricia Repko.)

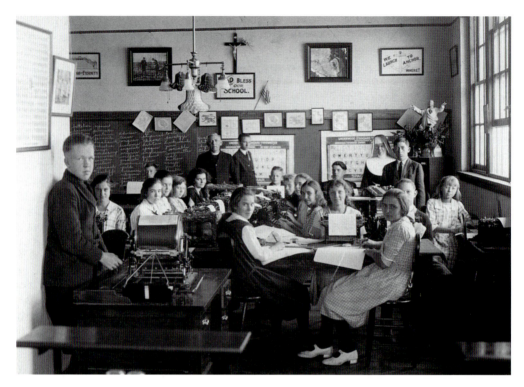

Source of Inspiration and Aid

From 1909 to 1934, Fr. William A. Wachter was pastor of St. Aloysius Roman Catholic Church at the corner of Beech and Hanover Streets. In 1912, he undertook what would become perhaps the most significant aspect of his legacy: the founding of St. Aloysius School. According to *Through the Years*, a church history compiled for the 150th anniversary of the parish, "Four large and two small classrooms were built on the first floor. Four small classrooms were built on the second floor (two at each end) and the large space in the middle was a 500-seat auditorium that was completed in April 1914 by Joseph Ginther, school custodian, and Harry Hartenstine, a master stonemason."

The pending completion of the second floor notwithstanding, the school opened in September 1913 with students in grades one through eight to be taught by nuns from the Franciscan Sisters of Glen Riddle, Pennsylvania. In 1919, as the academic program continued, a commercial school was begun to prepare young people for careers as bookkeepers and secretaries. The parish and school both flourished under Wachter's leadership, especially as an expanding population of Catholic immigrants from southern and eastern European nations arrived in Pottstown looking for work in its steel mills and factories. But the Depression hit hard. According to Father Wachter, the church finances finished in the black in 1933, in part, due to the "self-sacrificing sisters" and "improvements made by the custodian at no charge." Father Wachter also "didn't collect part of his salary" and "paid some bills out of his own pocket."

As he prepared to end his battle with cancer in June 1934, the front page of the *Pottstown Mercury* said, "Father Wachter's Condition Critical." According to the church history, more than 4,000 people passed by his coffin as he lay in state the night before his funeral. At his wish, he was buried in his garden at the base of the grotto, between the church and the school he built. The newspaper had many quotes from people who had known and loved him, speaking of his "kindness, tolerance, charity, and constant self-sacrifice," how he was a source of "inspiration and aid," and "just a wonderful man." Wachter is shown here near the blackboard with a class from the Commercial School at St. Aloysius, around 1930. It is believed this photograph was taken in one of the classrooms on the second floor. (Courtesy of Donna Brennan.)

Growing Deeper in Christ, Reaching Farther in Love

Like many congregations in Pottstown, First Presbyterian probably first met in Zion's United Church of Christ (Old Brick Church) on Hanover Street. Organized in 1848, the congregation's first building was at High and Evans Street. Rev. Matthew Meigs, founder of the Hill School, participated in the life of the young church. His son, John Meigs, who followed his father as "Master of the Hill," also took an active role in the church since the boys of the Hill School attended church at First Presbyterian Church until their own Memorial Chapel was built. The original building was replaced in 1889, and the new structure was sufficient for the congregation until the 1950s, when the decision was made to build a new sanctuary on land donated by Dr. Elmer Porter at 750 North Evans Street in the North End. The new church building was dedicated on June 2, 1963.

Rev. W. Carter Lester Jr. and Rev. Karen Pidcock-Lester have served as copastors since 1994. When they came to Pottstown, they were the first couple serving as copastors of a congregation in the Philadelphia Presbytery, which is the oldest Presbytery in the United States. They lead a congregation with the mission statement: "We are four generations of Christians seeking together to grow deeper in Christ to reach farther in love." Just before their arrival, the church had undertaken a major expansion and added a new Christian education wing, and the congregation continues to grow today.

The community strives to grow deeper in Christ with strong youth and educational programs, and they seek to reach farther in love in their work locally and in the world. Over the years, First Presbyterian has joined other congregations in Pottstown to establish the Pottstown Cluster of Religious Communities. They continue to be strong supporters of the Cluster and to host community meals for those in need on Thursday evenings. They support a tutoring and mentoring program at Barth Elementary School as well as after-school and leadership programs there. Beyond the Pottstown area, First Presbyterian sends out at least two youth and adult mission trips a year to help with the rebuilding or repairing of houses in places such as New Orleans and the Gulf Coast; Nashville, Tennessee; Lynchburg, Virginia; and Queens, New York. They have also sent three teams to Honduras in Central America to install water purification systems. (Photograph by Ed Berger.)

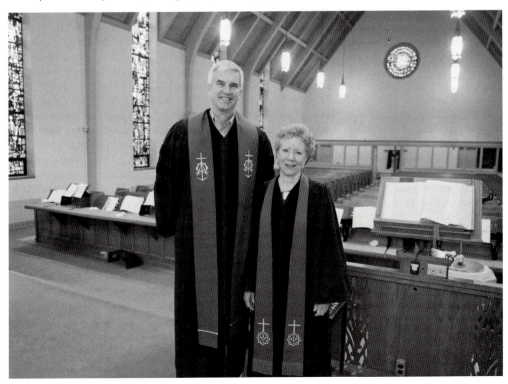

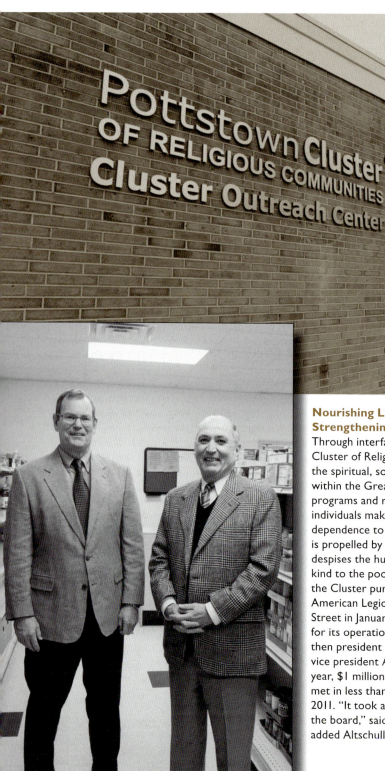

Nourishing Lives and Strengthening Families

Through interfaith cooperation, the Pottstown Cluster of Religious Communities addresses the spiritual, social, and basic needs of persons within the Greater Pottstown area. Their programs and referrals are coordinated to help individuals make real progress in moving from dependence to self-sufficiency. The Cluster is propelled by Proverbs 14:21: "He sins who despises the hungry; but happy is he who is kind to the poor." After a 15-year search, the Cluster purchased the George A. Amole American Legion Post at 57 North Franklin Street in January 2010 to provide more space for its operations. Under the leadership of then president George Bell (left) and then vice president Allan Altschull (right), a three-year, $1 million–capital campaign goal was met in less than two years between 2010 and 2011. "It took a lot of courage on the part of the board," said Bell. "We all did it together," added Altschull. (Photographs by Ed Berger.)

CHAPTER THREE

Educators and Innovators

The role of education in both public and private institutions is to pass on knowledge and cultivate values in young people that will lead to meaningful and productive lives within their families, their places of work, their communities, and the larger world.

According to Chancellor's *A History of Pottstown, Pennsylvania*, while there appears to have been a few small, tuition-based schools started by churches in the early part of the 19th century, it was not until the passage of Pennsylvania's Public School Law in 1834 that towns were allowed to set up taxing and administrative structures to build and maintain public schools. Even then, Pottstown officials did not vote to set up a public school system until four years later, in 1838. Over the next 50 years, many elementary schools were constructed, and it was in 1881 that the first diplomas were granted. A solid education began to be seen as a necessity on the path to a better life.

Two significant private schools were also founded in the mid-19th century. Rev. William R. Work founded the Cottage Female Seminary for elementary and secondary education on High Street, across from the present day Hill School. It ceased operating sometime after 1868. The Reverend Matthew Meigs founded the Hill School, the history of which is covered in more detail in this chapter. Wyndcroft School, founded in 1918 as "an open air school for healthy children on the porch of a Hill School building" is the only one of several private elementary schools to have survived. It is now located on Rosedale Drive and Wilson Street. Of the two parochial elementary schools in Pottstown proper—St. Aloysius and St. Peter's—only St. Aloysius, founded in 1912, remains. St. Pius X, a Catholic high school located just across the border in Lower Pottsgrove Township from 1955 to 2010, was consolidated with Kennedy-Kenrick to form Pope John Paul II High School in Royersford. Finally, the expansion of the West Campus of Montgomery County Community College has brought affordable and accessible higher education to western Montgomery County and served as an engine of economic revitalization.

Today, educators at all levels face the challenge of how to best teach and prepare young people and retrain older students for meaningful work in a world marked by rapid technological and scientific advances. It is a world in which the mastery of mathematical, scientific, and computing bodies of knowledge is urgently needed in the workplace. It is also a world that is highly interconnected, bringing a great diversity of people into contact with one another and creating an urgent need for an understanding of history, foreign languages, other cultures, literature, and human behavior. Here in Pottstown, it is the challenge of schools and educators to expose citizens of all ages to the possibilities of the worlds beyond their borders and to tap into and inspire the innate curiosity of every person who comes through their doors, especially those for whom economic hardship daily puts the ideals of education to its ultimate test.

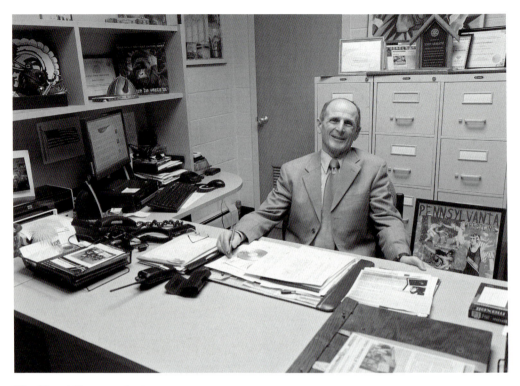

The Great Communicator

John Armato began as a teacher of oral communication in the Pottstown schools in 1969, right out of college at East Stroudsburg State, where he was on the wrestling and debate teams. He was not even 20 years old. "I guess my parents wanted me out of the house when I was just a toddler because I started school pretty early," he said. "I don't think the district knew it when they hired me, but I wasn't much older than the kids I was teaching." Since then, Armato has served in numerous capacities: athletic director, head of student activities, and most recently as director of community relations. For the past two years, Armato has continued this work in an unpaid capacity, regularly turning out positive news of student achievements; school events; awards; and recognition for students, faculty, and staff to local media and bloggers.

His longest-running assignment, though, has been as the assistant varsity wrestling coach. Over the course of 43 years, he has mentored hundreds of young men, including champions such as the late Jeff Green, a member of the 1996 US Olympic wrestling team, and Seth Ecker, a two-time NCAA Division III national champion at Ithaca College.

In 2012, Armato was named Rotary Person of the Year and honored at a ceremony at Pottstown's Riverfront Park. There, he was feted by the community and recognized for his many contributions. Armato is a member of the Pottstown Downtown Improvement District Authority, the Pottstown Civil Service Commission, and the Foundation for Pottstown Education. He used to be a board member of Preservation Pottstown as well. At the heart of his involvement in the community is how much he cares about other people. That night at Riverfront Park, as reported by Evan Brandt in the *Mercury*, Anna Mae Bieber told how she did not get to graduate with her class in 1951 because of the death of her mother; John, however, worked behind the scenes so that she could be surprised with a diploma at a class reunion.

Armato's positive spirit is contagious. When asked how he is doing, he is almost guaranteed to respond, "Fantastic!" His own physical fitness contributes to his mental attitude. He has been a competitive runner and triathlete for years. Even though he is originally from Brooklyn, Armato signs all his correspondence with, "Proud to be from Pottstown." (Photograph by Ed Berger.)

CHAPTER THREE: EDUCATORS AND INNOVATORS

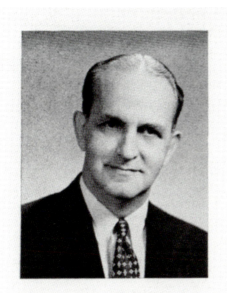

Mr. Stanley I. Davenport, Jr.

Principal

SID
The 1955 and 1965 Troiad yearbooks were dedicated to the high school principal affectionately known as SID. His full name was Stanley I. Davenport Jr., and the high school performing arts center is named for him. Patricia Nester Salanek, from the class of 1964, recalled, "Everyone loved Mr. Davenport, a quiet, kind, unassuming man with the highest authority, yet always a kind demeanor. He was very fair, always approachable, and very respected . . . never feared." (Courtesy of Patricia Repko.)

PEAK Performer
Although he only recently became the superintendent of the Pottstown Schools, on the brink of retirement, Dr. Jeffrey Sparagana is perhaps best known for his leadership as director of education in creating the school district's highly regarded prekindergarten readiness program. PEAK, which stands for Pottstown Early Action for Kindergarten, creates partnerships between the district and borough preschools to ensure that the youngest students are prepared to succeed in kindergarten. (Courtesy of Pottstown School District.)

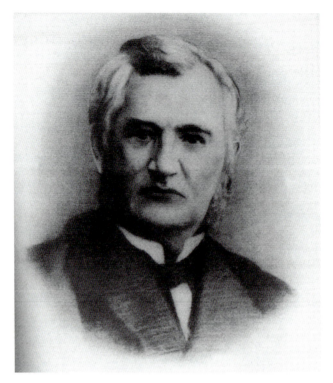

"A Climate of Uncommon Salubrity"

In early 1851, the Reverend Matthew Meigs purchased the N.P. Hobart estate to establish a boarding school for boys and young men on the outskirts of Pottstown. The 36-acre location was considered out in the country. In his announcement of the new school, he wrote, "The institution is situated on a commanding eminence, affording an extensive and beautiful prospect of the surrounding country." He went on to write, "The climate is one of well-known and uncommon salubrity." Today, the Hill School is a preeminent boarding school attracting students from across the United States and around the world. Its arts and athletic facilities are a resource for the Pottstown community. The school itself stands upon a hill as an educational anchor at the east end of High Street, Pottstown's main downtown thoroughfare.

In the beginning years of his career, Matthew Meigs vacillated between academic and religious life. He graduated from Union College in 1836 with a degree in language and linguistics, and by 1839 he was ordained a Presbyterian minister by Union Theological Seminary. He then became a professor of classical languages at the University of Michigan and, later, a minister of a congregation in Pontiac, Michigan. This was followed by a position at Winchester Academy in Virginia and a post as the president of Newark Academy in Delaware. Then, after serving just eight months as president of Delaware College, where it appears he wanted to change the method of instruction but lacked the funds to do so, he lit upon the idea of opening his own school in Pottstown, which had a stop on the Reading Railroad. The region was booming due to the 1842 completion of the railway between Philadelphia and the Pennsylvania coal region.

At the start, the enrollment was about 10 to 12 students, and Meigs limited it during his tenure to about 30 students. The institution placed its emphasis on character and moral development based on nondenominational Christian values, and Meigs's philosophy depended upon a family atmosphere, with the faculty taking all of their meals with the students. The all-girls Cottage Seminary across the street provided opportunities for appropriate social interaction and mischievous activities as well.

Despite the inspiration it took to start the Hill School, founder Matthew Meigs perhaps suffered from waning interest and a failure to delegate, which posed challenges to the school's long-term viability in the early years. It would take the leadership and longevity of his son John to firmly establish the institution among the elite boarding schools in the United States. (Courtesy of the Hill School.)

CHAPTER THREE: EDUCATORS AND INNOVATORS

The Professor

In 1876, at the tender age of 24, John Meigs, the sixth child and fourth son of Matthew Meigs, took over as headmaster at the Hill School when his brother George became too sickly to continue. John had been teaching at Lafayette College, his alma mater, and became known simply as "the Professor." When he took over, part of the campus had been sold off, and the school was down to 12 acres with 25 students, three faculty, and eight buildings.

In 1884, Matthew Meigs sold the school to John, paving the way for the notable expansion of the campus and the student body that became John's hallmark. The younger Meigs gradually placed more emphasis on college preparation and getting the school's graduates into what would become known as the Ivy League schools. While there were 67 students in 1885, there were 228 in 1901, and 347 in 1911, the end of the Professor's tenure. John Meigs continued to build and rebuild, even through three devastating fires in 1884, 1890, and 1901.

When heart trouble began plaguing him in 1907, he took several trips to German sanitariums to heal himself. One fall evening in 1908, when he and his wife, Marion, had recently returned from one of these trips, Meigs was in his study when he heard the strains of a marching band approaching the campus. Hill students poured out of their rooms to see a parade on High Street headed toward the campus. The Professor was much revered and loved by the people of Pottstown, and they were celebrating his safe return from Europe. Meigs, a progressive Republican in his day, and his wife had helped establish the Boys' Free Reading Room, the Bethany Mission, and the YMCA and YWCA in Pottstown. That night, speakers honored him and spoke of how proud and grateful they were for what he, his wife, and the school had done for the citizens of Pottstown.

At 10:00 p.m. on Monday, November 6, 1911, Prof. John Meigs died of a heart attack. Following an interim successor, his own son Dwight would take over as headmaster from 1914 until 1922, but that would be the end of the Meigs family leadership at the school. (Courtesy of the Hill School.)

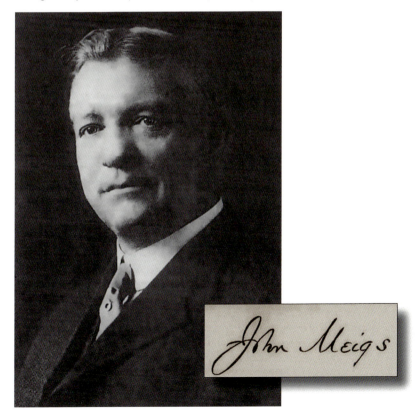

37

"Mrs. John"
John Meigs, "the Professor," married Marion Butler of New York in the summer of 1882 in Berlin, following her European training in music and piano and attendance at a female seminary in Batavia, New York. She became known affectionately on campus as "Mrs. John" and is shown here with her granddaughter Marcia Meigs, with whom she had a very close relationship. John and Marion Meigs were instrumental in establishing the Boys' Free Reading Room, Bethany Mission, YMCA, and YWCA in Pottstown. (Courtesy of the Hill School.)

JAMES ALBERT MICHENER, A.B.
SWARTHMORE COLLEGE, '29

Came to The Hill in 1929 in the Department of English; Phi Beta Kappa.

They Knew Him When
Fresh out of college, the future Pulitzer Prize–winning novelist James Michener taught English for two years (1929–1931) at the Hill School. The material for his 1947 best-selling novel, *Tales of the South Pacific*, came from his stint in the Navy during World War II. The book would later be adapted by Rodgers and Hammerstein into a musical, a perennial favorite on Broadway and in theaters and high schools around the country. (Courtesy of the Hill School.)

CHAPTER THREE: EDUCATORS AND INNOVATORS

A Lifetime of Service
Willis Strawther was a butler and doorman at the Hill School for an astounding 67 years, from 1900 to 1967. This first image shows him early in his career, in about 1915, and the second captures him dressed up in a suit and tie on the occasion of his 50th year of service at the school. Strawther can also be seen with the Second Baptist Church choir on page 26. (Courtesy of the Hill School.)

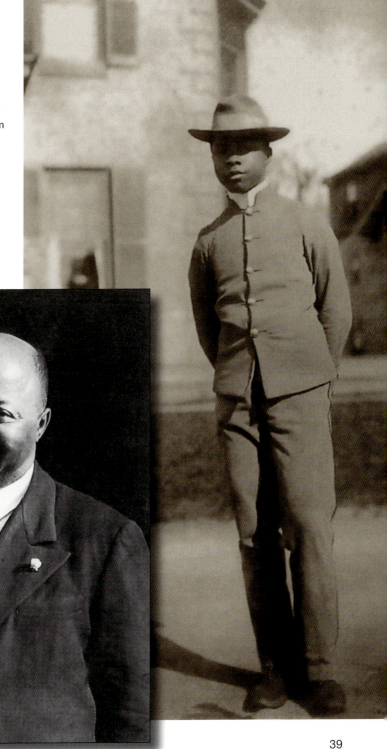

LEGENDARY LOCALS

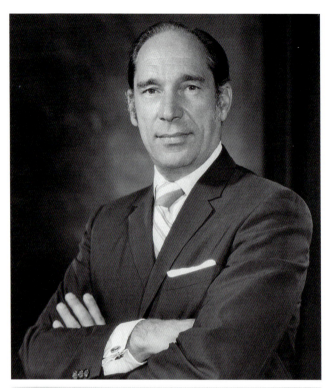

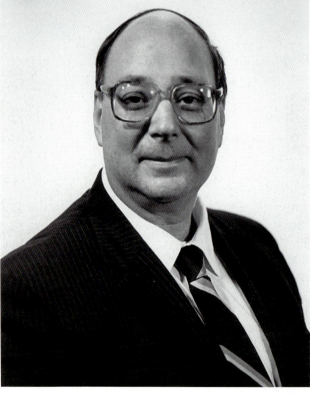

Community College Visionaries

Dr. Leroy Brendlinger, left, was the founding president of Montgomery County Community College (MCCC), officially established in 1964 and offering classes in rented space in Conshocken. The Central Campus in Blue Bell opened in 1972 with a mission to offer high-quality, affordable, and accessible educational opportunities. By the 1980s, though, growth and traffic made Blue Bell less accessible for many county residents. Doctor Brendlinger, as president emeritus, nurtured the Pottstown Center Advisory Committee through the 1980s, gathering data and assessing options while increasing credit course offerings in several Pottstown-area locations. Dr. Edward Sweitzer, below, the third president of MCCC from 1988 until his death in 2000, oversaw the actual expansion of the West Campus into Pottstown. By the fall of 1996 a new building, now known as South Hall, opened for classes on College Drive. (Both, courtesy of the Brendlinger Library Archives & Special Collections, Montgomery County Community College.)

CHAPTER THREE: EDUCATORS AND INNOVATORS

Shepherding the Expansion

Dr. Dean Foster was administrator of the West Campus from 2002 until 2009. In partnership with private developer Gary Silvestri, MCCC occupied the former Kiwi Shoe Polish factory at 16 East High Street (now North Hall), moving into the first floor in 2006 and the second floor in 2009. An arched pedestrian walkway connected North and South Halls. Foster was instrumental in making the West Campus truly a multibuilding campus.

The college also owns 140 College Drive, a former PECO substation that is now home to the Schuylkill River National & State Heritage Area offices, the Schuylkill River Academic and Heritage Center, and the future site of the college's environmental science program. In 2012, the college opened its University Center in a former rail freight station at 95 South Hanover Street. Through its expansion, the institution has preserved three historic buildings in dramatic fashion. (Right, courtesy of Dean Foster; below, courtesy of Montgomery County Community College.)

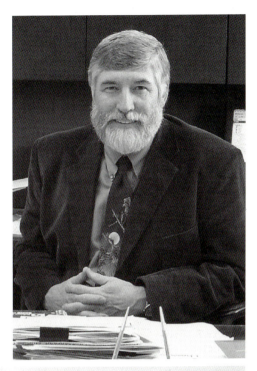

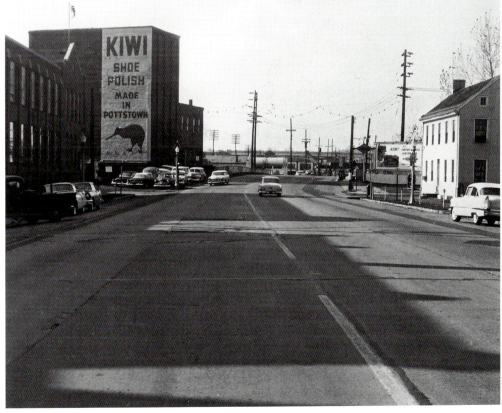

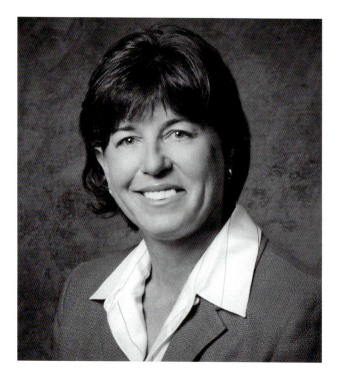

Higher Education Trailblazer

Since 2001, Dr. Karen Stout has led Montgomery County Community College through an era of enormous growth, not just in enrollment and the maintenance and expansion of the Central and West Campuses but also in the development of curricula and programs that put MCCC at the forefront of higher education. MCCC regularly receives national accolades for community service, college-graduation success rates, climate sustainability, and the use of technology. Just a stone's throw from Pottsgrove Manor, this campus of higher learning and innovation stands as the western educational anchor of High Street, the counterpart to the Hill School at the eastern end.

For five consecutive years, both campuses have made the President's National Honor Roll for Community Service, which includes documented hours put in by students. One such program, in partnership with the Pottstown Area Health & Wellness Foundation, allows students studying to be dental hygienists to apply dental sealants to young children's teeth in Pottstown.

Under Dr. Stout's leadership and that of the college's board of trustees, MCCC made a commitment to study the graduation rates of its students based on various criteria. They used hard data to develop strategies to ensure the success of the at-risk students they serve. "We have a very strong research and technology faculty," said Dr. Stout. Their intervention strategies have resulted in MCCC being named a 2001 Leader College by Achieving the Dream.

MCCC has also received recognition from Second Nature for its climate leadership. The college has a President's Climate Council, which meets four times per year to continually hone energy-saving activities on both campuses, and the adaptive reuse of multiple buildings on the West Campus is the ultimate form of recycling.

Finally, MCCC's outstanding technology faculty and staff put it consistently in the Center for Digital Education's top 10 colleges in the nation for their use of technology. Schools are ranked based on their websites, the use of technology in the classroom, and the way rooms and labs are equipped, among many other criteria. Their entire information-technology infrastructure is assessed, and MCCC keeps coming out near the top. All of these achievements would not be possible without a leader like Stout, who is determined to see her institution remain at the cutting edge in service to those who want an affordable, accessible education close to home. (Courtesy of Montgomery County Community College.)

CHAPTER FOUR

Titans of Trade

Small, family-owned businesses are the bedrock of the nation's economy. They make up the commercial and financial life of rural hamlets, small towns, suburban shopping centers, and urban neighborhoods across the country. Behind every one of these small businesses is a risk taker. Behind every one of these *successful* small businesses is a risk taker who is also an independent, clear thinker and a creative problem solver, able to enlist the support of others to keep the venture going.

At some point, the businesses owners featured here—or their ancestors—had an idea and decided to take a chance, strike out on their own, and hang out their shingle. The phrase "to hang out a shingle," traditionally referred to a doctor or lawyer hanging a sign with the name of the practitioner at his place of business. Implied here is the notion that an entrepreneur's reputation—his or her name and family honor—is at stake. If they did not provide a valuable product or service at a reasonable price and in a congenial manner, the business would not survive. This holds true today, perhaps more so due to the ease and speed with which word-of-mouth marketing can be communicated through social media.

The Pottstown businesses featured here run the gamut of products and services: home design, construction, carpeting, landscaping, plumbing and heating, clothing, jewelry, hair care, beer, bras, tobacco, prescriptions, health food, motorcycles, legal services, locksmith services, and the town paper. Also included are the people in the organizations that support existing and new businesses in an effort to keep them in Pottstown or entice them to expand or relocate here, trying to get the economic engine firing on all cylinders again after the manufacturing losses of the 1970s and 1980s.

While many of Pottstown's business owners may feel the weight of a long-term local and global economic recession every day, they continue to open their doors and to welcome their customers and clients with a smile and the best products and know-how that money can buy. They continue to take on the challenges and responsibilities of managing income, expenses, inventory, and advertising while adapting to change, both good and bad, in their specific fields as well as in the local and global economies. They continue to give back to the community through volunteerism and acts of charity, both large and small. And they continue to provide a livelihood for their employees; it is not just their own financial well-being that is at stake. Families and, indeed, whole communities depend on small-business owners for all this. It is a weighty position to be in, but these entrepreneurs have taken up the gauntlet put down almost 300 years ago when someone built a gristmill near the Schuylkill River and the Manatawny Creek because people needed their wheat ground—people needed to eat—long before even the Potts family had come onto the scene.

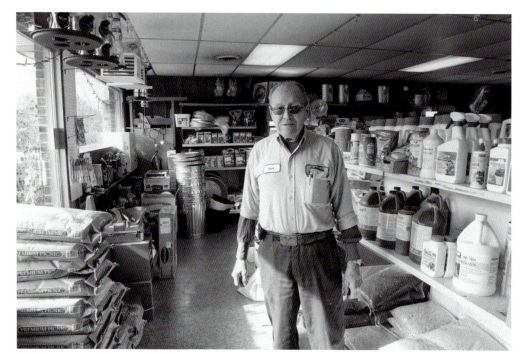

Oldest Business in the United States?

The Pottstown Roller Mills, run by Henry "Hank" Saylor, has been in his family since the 1920s. But it was around way before that, having been started in 1725, seven years before George Washington was born and 27 years before Pottsgrove Manor was built. Some locals claim that it could be the longest continuously operating business in the country.

A roller mill, or gristmill, was a place where grain was crushed between revolving stones, powered by water. The grain was then put through sieves that separated it into the middlings, the grain, and the flour or feed. The original Pottstown Roller Mills at Hanover and South Streets was located near the point where the Manatawny Creek met the Schuylkill River. Farmers brought their grain to the miller to have it ground into flour. According to Chancellor's *A History of Pottstown*, although the original miller is not known, the mill was owned by Jesse Ives from the late 18th century through the mid-19th century. It then passed through the hands of Henry and Jacob Gabel and a succession of other partnerships. By the mid-to-late 1920s, Frank C. Bechtel, Saylor's maternal grandfather, took over. As of the 1950s, the mill was being run by Saylor's mother, Catherine (Bechtel) Saylor and an uncle, Carl W. Boyer.

While the original building has been converted to apartments and is listed in the National Register of Historic Places, the present location of the Pottstown Roller Mills is not far away, at 625 Industrial Highway. Saylor and his brother Charles made settlement on the land just days after Hurricane Agnes stormed through the area in 1972. In 1974, they opened for business in the building that stands there today.

"There just aren't many farms anymore," said Saylor. At 82, he is the one running the business today with his son Douglas. "There was a time we dealt in chemicals, supplying Firestone and a lot of other industries in town like Flagg's and Doehler's. Lots of those employees were also our customers, who had five, six, ten acres outside of town with a garden, pigs, and chickens. You don't see that anymore. We sell a lot more garden mulch, sand, and stone, but none of it takes the place of doing business with those bigger industries." (Photograph by Ed Berger.)

CHAPTER FOUR: TITANS OF TRADE

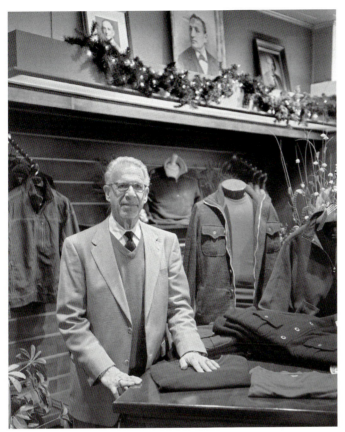

Weitzenkorn's
When Abraham Weitzenkorn immigrated to America in 1857, little did he know that he would open a clothing store, founded on honesty, service, and quality, that would be passed down from generation to generation. Weitzenkorn's opened in 1864 and claims to be the second-oldest men's store in the country. Today, it is run by brothers Marc and Gregg Weitzenkorn and Gregg's son Aaron, the fifth generation. Interspersed throughout the store are artifacts from over the years, including a large canvas umbrella with the Weitzenkorn name on it. "My grandfather or great-grandfather gave these out to farmers whose fields were near main roads to put on their tractors for shade. It was good advertisement," said Marc, shown here. (Photographs by Ed Berger.)

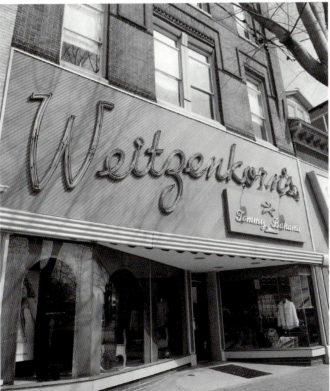

45

LEGENDARY LOCALS

Jewelry for Generations
Jewelry comes in all shapes, sizes, and materials. Even in a tough economy, buyers can find something in their price range that can be passed down from generation to generation. Doris Powell, owner of Warrick Jewelers at 251 East High Street, started working part time for Walter M. Warrick in 1965. Two decades later, she bought the business, which now offers women's clothing, handbags, and repairs. "We're more than just jewelry," she said. (Photograph by Ed Berger.)

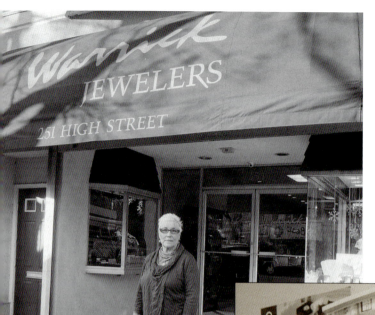

Rich Ranieri
For more than 30 years, Rich Ranieri has run a family-owned, full-service carpet-and-flooring store at 218 East High Street. Not only do they offer a wide array of quality, name-brand carpet; ceramic tile; and hardwood, laminate, vinyl, bamboo, and cork flooring, they also boast competitive prices and unrivaled customer service. "We make sure it's done right," says Ranieri. "That's what my business is all about." (Photograph by Ed Berger.)

A Walk-In Humidor
Thomas Cole created the Cole Tobacco Company in the late 1870s, hiring several employees and making cigars out of a shop near the Shuler House. Today, the husband-and-wife team of Cortney and Cindy Brower operates Coles at 215 East High Street. They took it over in 2006 from Cortney's parents, Joyce and Robert, who had been in business since 1987. Cindy is president of the Pottstown Downtown Improvement District Authority. (Photograph by Ed Berger.)

Main Street Manager
The Pottstown Downtown Improvement District Authority, located at the Pottstown Visitors' Center at 17 North Hanover Street, has had several Main Street managers over the years, but none like Sheila Dugan, who was hired in 2012. She is relentless about making High Street safe, clean, and welcoming to businesses and visitors. "I live here, work here, and have a business here. I have a big stake in the community," she says. (Photograph by Sue Repko.)

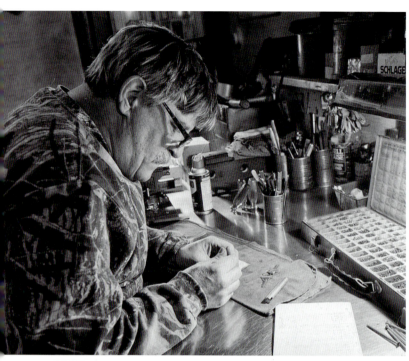

Under Lock and Key

Since 1986, locksmith Gregory R. Carter has been helping Pottstown families and businesses keep their loved ones and possessions secure. Greg and Jean Carter work in tandem in their historical building at 127 North Hanover Street, where Greg has gotten a reputation for being able to handle old-time keys and locks. People and restoration companies facing challenges with older locks travel from far and wide for his expertise. (Photograph by Ed Berger.)

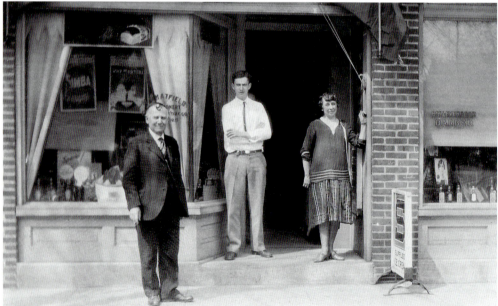

The Hatfields

Around 1925, James and Margret (Prutzman) Hatfield built a store and home at 127 North Hanover Street. They sold dry goods and newspapers; briefly, there was a gas pump out front. Their younger son Arthur ran the store on his own when his mother passed away in 1959. Pottstonians of a certain age may recall Arthur, shown here with his mother and an unknown man, selling penny candy behind the counter. (Courtesy of Greg and Jean Carter.)

P. Richard Frantz

Architect P. Richard Frantz of the American Institute of Architects is a problem solver, designing new construction, additions, renovations, and historical restorations. He began his practice in Pottstown in 1967, and his clients have included the Hill School, Pottstown School District, and Creative Health Services, among many others. He is an active member of the Building Industries Exchange and Rotary Club and serves on the Historic Architectural Review Board, Board of Pottstown Memorial Medical Center, and PAID, Inc. (Courtesy of P. Richard Frantz.)

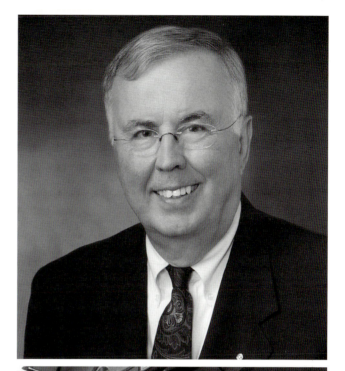

The O'Boyles

After 24 years on East Seventh Street in Pottstown, John and Pam O'Boyle of J.O.B. Design & Construction, Inc., took a chance, remodeling the historic Van Buskirk home at 64 North Hanover Street for their headquarters and preserving an impressive array of hardwood floors, doors, and moldings. John, past president of the Building Industries Exchange, oversaw construction of the World War II memorial in Memorial Park in 2008. (Photograph by Ed Berger.)

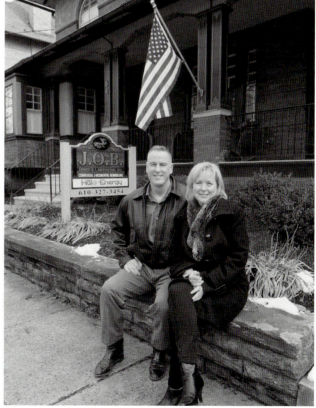

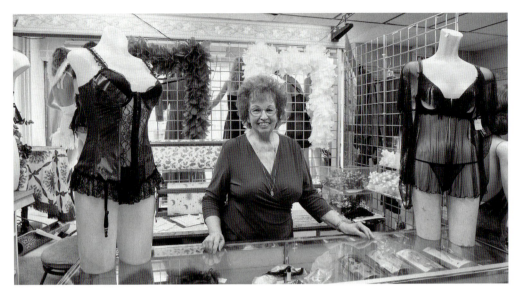

Custom Comfort for All Shapes and Sizes

In 1972, Jean Schock was running the Rose Millinery Shop at 8–14 North Hanover Street when a 65-year-old lingerie salesman came calling. He claimed that hats were going out of style and lingerie was in. Schock believed him, and pretty soon the "lingerie just walked out the door." More than 30 years later, Schock still sells lingerie at Jean's Lingerie & Boutique across the street at 27 North Hanover. More importantly, she has developed a reputation as the best bra fitter around. Early in her career, when she started selling Brantly bras, the company required her to attend their training school in Texas. "I was in class all day long," she said while demonstrating the suspension, lift, and thrust principles that N.O. Brantly, an elderly aeronautical engineer who invented backhoes and helicopters, had used in his design for bras for larger women. (Photographs by Ed Berger.)

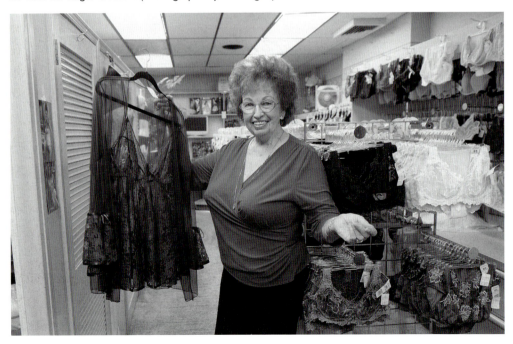

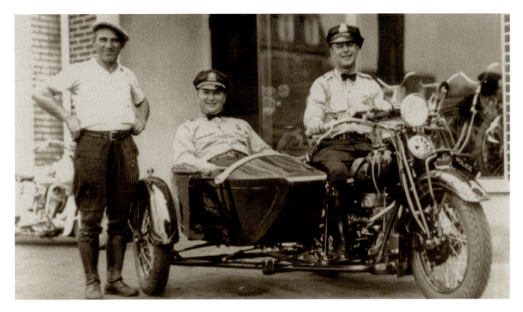

Cross-Country Dreaming

Randy Kiss is the third generation to operate Frank Kiss & Company, a motorcycle dealership, at 18 East High Street. His grandfather Frank Kiss Sr. was a Hungarian immigrant, originally named Kish, who landed at Ellis Island. By the time he checked in to start his version of the American dream, he was a Kiss. Frank Jr. and Randy were born into the business. "It's all I know. All I've ever done," said Randy. "I'm very lucky. I had an excellent family that gave me the opportunity to do what I do. I got several more years, then I'd like to have some type of retirement. My dream is to ride a motorcycle across the country and see the United States. I'd love to experience that. I've always been in Pottstown." Kiss Sr. is shown above, left; Earl Rhoads is on the right. The man in the middle is unidentified. (Above, courtesy of Randy Kiss; bottom photograph by Ed Berger.)

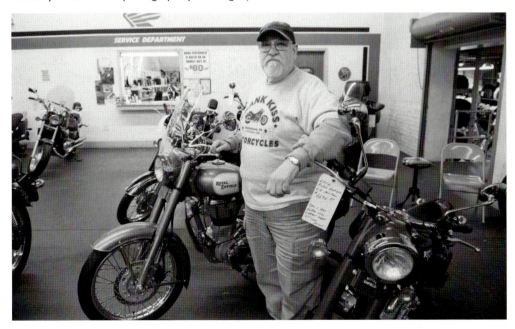

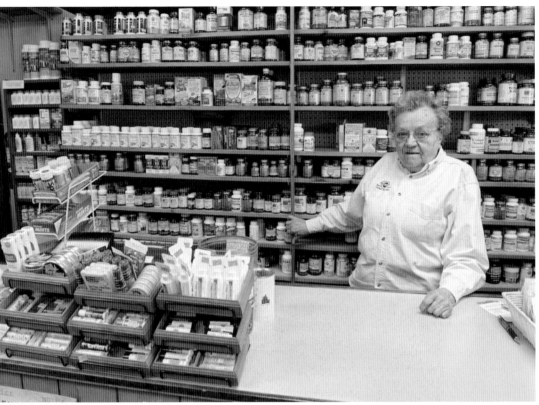

Janet's Nutritional Foods
Shortly after opening in the cozy shop at 26 South Charlotte Street in March 1976, Janet Garner thought she had made a mistake. "Health food was associated with hippies. Everybody thought I'd lost my mind, but I found it again." Carol Landis joined the company that same year, and Janet's Nutritional Foods has been holding steady ever since, offering vitamins, dry goods, and a variety of refrigerated and frozen foods. (Photograph by Ed Berger.)

Looking Good, Feeling Good
For the past 27 years, Emilie Kurtz has owned her own business—Emilie—specializing in nonsurgical hair-loss solutions, hair styling, coloring, and spa treatments. The interior is quaint and eclectic, while the approximately 10 distinctive colors on the facade of her building at 133 King Street have garnered a mention at PaintedLadies.com, a well-known website dedicated to Victorian architecture. Kurtz is shown here with Hershey Bear and Ginger. (Photograph by Ed Berger.)

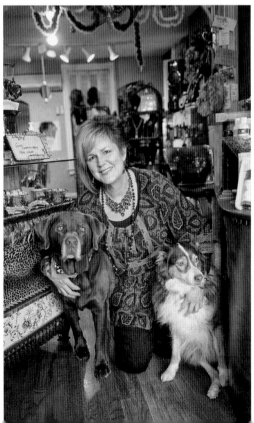

Legal Eagles

Jack Frederick Wolf began to practice law in 1973, right out of Dickinson School of Law, in office space provided by Henry Markofski. Within a year, he hung out his own shingle at 158 North Hanover Street and fully launched his general practice firm, Wolf, Baldwin & Associates, which includes his son Levi, also an attorney. Jack's wife, Gayle, and daughter-in-law Amy handle the office management and billing.

As might be expected at the time, Wolf's path to a career in law was interrupted by military service. After graduating from Albright College in 1967 with a degree in political science, he studied just one year at Dickinson before serving in the US Navy, where he received the Meritorious Service Medal in 1971. Later that year, when his stint was up, he returned to Dickinson and earned his juris doctor in 1973. Then, with a wife and child to support, he began his own practice. Even so, he has been significantly involved in the community, serving as borough council president from 2000 to 2008, president of the school board, and president of Congregation Mercy and Truth synagogue. He has also served on or been recognized by various charitable and community organizations, including Alternatives, the Pottstown Optimist Club, the Old Pottstown Preservation Society, and Preservation Pottstown.

Like many area immigrants, Wolf's grandfather came to Pottstown from Czechoslovakia, then part of the Austro-Hungarian Empire, in 1884. Jack Wolf was born in Philadelphia, where his father was a dry cleaner. After a series of job changes because of the Depression, his father bought a gift shop in Pottstown, calling it Wolf's China & Glass. It was located at 155 East High Street (1948–1957) and then at 207 East High Street (1957–1978.) In 2012, Wolf, Baldwin & Associates, PC renovated and moved from its longtime location on Hanover Street into the Spanish Colonial–style building at 800 East High Street, across from the Hill School and the post office. (Photograph by Ed Berger.)

J. Aram Ecker

For over 85 years, the Ecker family has kept the heating, cooling, and plumbing systems in Pottstown–area homes humming along. J. Aram Ecker (above) followed in the footsteps of his father and grandfather, apprenticing to his father at the age of 12. By the age of 21, he was a master plumber and had absorbed the knowledge about running a successful business based on honesty and reliability. They service well pumps, water heaters, heating and cooling systems, and plumbing fixtures, and they do sewer cleaning and replacement in Pottstown, Boyertown, Gilbertsville, Limerick, Royersford, Phoenixville, and the surrounding area. Ecker also continually gives back to the community. In 2010, he was named Rotary Person of the Year. He is shown at right with his stepson, Jarred Haring. (Above, courtesy of Donna Ecker; right, photograph by Ed Berger.)

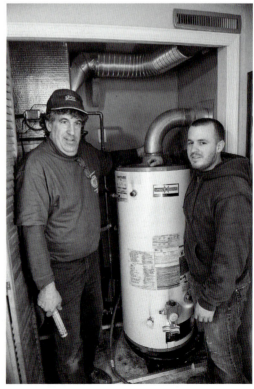

CHAPTER FOUR: TITANS OF TRADE

A Barber in a Good Spot

Charles Harris used to be a full-time service technician at Doehler-Jarvis before he retired. But then he found a "good spot" for a business he had always wanted to run. For the past 21 years, retirement has included running Charles Barber Shop at 600 King Street, where Amole's grocery store used to be. How long will the soft-spoken Harris keep working? "Long as the Lord lets me keep cutting hair." (Photograph by Ed Berger.)

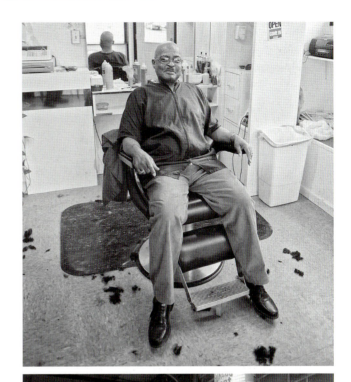

Looking for a River View

Although Bill Ludy has owned Riverside Beverages for only about seven years, the business has been around for at least sixty. "I kept the name so customers would recognize it," Ludy said. In its current incarnation, it is nowhere near the river but is located at the former Rosenberry's Supermarket at 375 North Hanover Street. The very first location, though, was across the Hanover Street Bridge, where Riverside Bar now sits. (Photograph by Ed Berger.)

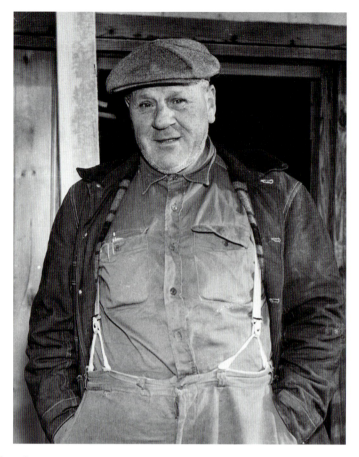

A.D. Moyer Lumber
Long before the modern recycling movement, Amandus D. Moyer understood there was money to be made in wisely reusing lumber. In 1939, he bought the wooden roller coaster at Sanatoga Amusement Park, demolished it, and moved all of the lumber to his home in Gilbertsville, the headquarters of A.D. Moyer Lumber at 1200 East Philadelphia Avenue. When that wood was sold, he went to the Pennsylvania coal region and bought a coal cracker, which he dismantled and again took back to Gilbertsville to sell. By the following year, he was selling new lumber, and the business has continued to grow until this day, adding products and services for home owners, home builders, and other businesses in need of construction advice and materials. In the mid-1950s, his sons Francis and Donald joined him in the business, and by 1974 they built a lumberyard just across the Pottstown border at 300 Armand Hammer Boulevard, where there once had been a baseball field. Over time, with the passing of Donald and Francis, their sons (Scott and Terry, respectively) came into the business, which they continue to run today.

During the 1980s, several expansions transformed the Gilbertsville store into an 8,000-square-foot complete home center. The size of the Pottstown store was doubled to 12,800 square feet, and a second, 8,000-square-foot warehouse was added. By the end of the decade, the millwork shop was enlarged in Gilbertsville to increase storage area. During the 1990s, the Moyers focused on computerizing the business with design capabilities for decks, garages, Andersen windows and doors, paint-color matching, and kitchens and baths. Today, A.D. Moyer offers knowledgeable, reliable service with the highest-quality products while keeping on the leading edge with the incorporation of the latest design technology. Inspired by the man who first took apart the Sanatoga roller coaster, A.D. Moyer Lumber has been bringing the best of old-world service and innovation to families and businesses in the Pottstown and Gilbertsville area for more than 74 years. (Courtesy of A.D. Moyer Lumber and Hardware.)

CHAPTER FOUR: TITANS OF TRADE

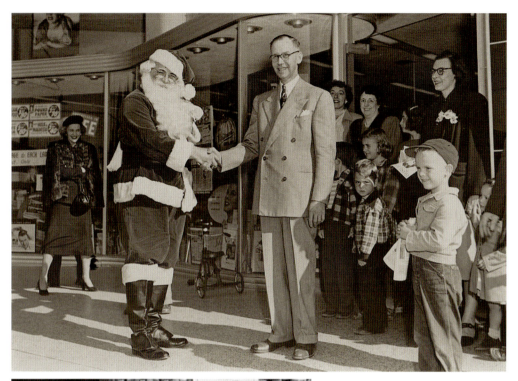

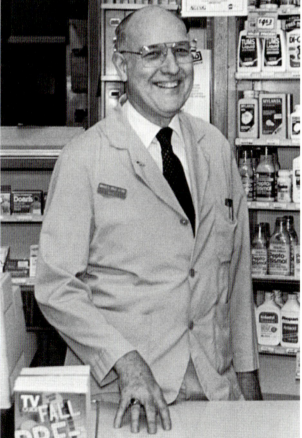

Bause's Super Drug Store
Daniel Bause Sr. graduated from the Philadelphia College of Pharmacy (PCP) in 1925 and went to work for Dentler's in Pottstown before getting laid off around 1932 or 1933. Two days later, he got a call from Lucy Nyman in Boyertown, who needed help at her store after the death of her pharmacist husband. By 1935, Bause opened his own store in Boyertown. In 1950, he and Daniel Bause Jr., a newly minted PCP graduate, built a brand-new store on Charlotte Street in Pottstown. Bause Sr. is shown here greeting Santa on opening day. Following a grease fire in 1967 and the death of Bause Sr., the Pottstown store was rebuilt. It was sold in 1971 to George Koffs and was renamed Professional Pharmacy. Bause Jr. is shown here on his last day in the Boyertown store in 1991. (Courtesy of Daniel Bause Jr.)

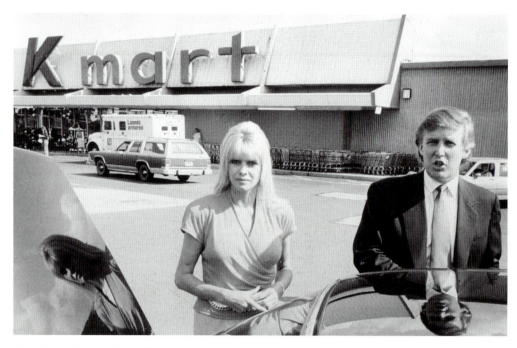

The Donald Goes Shopping
When John Strickler, veteran photographer for the *Mercury*, got a tip about Donald and Ivana Trump shopping at the Sanatoga Kmart in 1991 for Donald Jr., who had just started at the Hill School, he found a Mercedes with New York plates in the parking lot and bided his time. The photograph caused media mayhem, appearing in papers around the country and providing fodder for the late-night talk shows. (Photograph by John Strickler.)

Shandy Hill
During the depths of the Depression, Shandy Hill was a cofounder, along with financial backer William M. Hiester, of the Pottstown *Mercury*, whose first issue was published on September 29, 1931. Hill would remain its editor for 36 years. In his autobiography *Dear Sir, You Cur*, he wrote that he told civic groups the paper "would be the people's guardian, the defender of truth, the watchdog of the community." (Courtesy of the *Mercury*.)

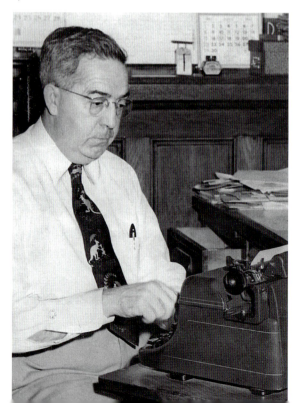

CHAPTER FOUR: TITANS OF TRADE

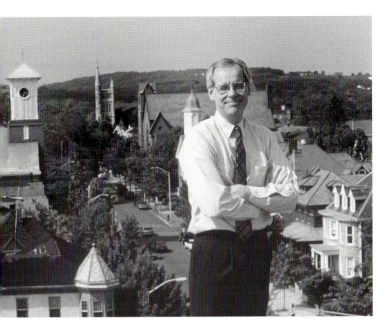

Save Our Land, Save Our Towns
Tom Hylton came to work for the Pottstown *Mercury* in 1971, spending a month sorting sales slips at a card table before someone got fired and a news-reporter slot opened up. He was given the freedom to write about what interested him, and his editorials advocating the preservation of farmland and open space in southeastern Pennsylvania won a Pulitzer Prize in 1990, well before "smart growth" became planning buzzwords. (Courtesy of Tom Hylton.)

Big SCORE for Business
Carl Landis (left) and Dick Ludwick are the two remaining, active members of the founders of Pottstown SCORE Chapter No. 594. SCORE is the nation's largest volunteer business-counseling service and helps those in business or those thinking about starting one. Pottstown SCORE is located in the New York Plaza Building at 244 East High Street. Landis is a certified financial planner; Ludwick ran Ludwick Motors from 1961 to 2000. They have counseled hundreds of clients since 1991. (Photograph by Sue Repko.)

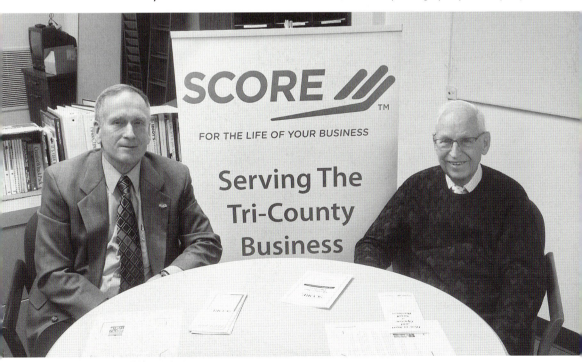

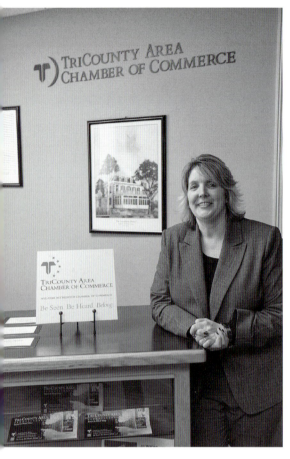

Taking Care of Business
One never knows when an internship will lead to a career. In the summer of 1990, Eileen Dautrich worked for a satellite office of the TriCounty Area Chamber of Commerce. After college, she returned and worked in various capacities before moving her way up to president in 2010. The chamber enhances economic opportunity throughout the region from their suite in the historic Security Trust Company building at 152 East High Street. (Photograph by Ed Berger.)

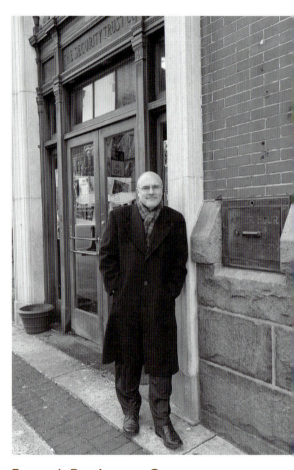

Economic Development Guru
After a long wait, the arrival in November 2011 of Steve Bamford, the first economic development director for the newly re-formed Pottstown Area Industrial Development Corporation, was met with a collective sigh of relief. Steve is responsible for retaining and bringing new businesses and jobs to Pottstown. With a masters of business administration from the University of Delaware, he brings more than 20 years of private-sector and government experience to the task. (Photograph by Ed Berger.)

CHAPTER FIVE

Creators of Art and Culture

A fundamental part of being human is the creative expression of emotions and ideas. Human beings have been expressing themselves since they first began drawing figures on the walls of caves, or humming to soothe an infant, or dancing to commemorate the change of seasons. Through song, poetry, storytelling, painting, acting, photography, sculpture, dance, and the creation and playing of musical instruments, people express their joy, sorrow, physical pain, humor, political unrest, and their praise to a higher being.

Because the history of Pottstown is so closely associated with the production of iron and steel and the rise of manufacturing, it is perhaps understandable that the town's historical position as a regional center for the pursuit and enjoyment of the arts might be overlooked. Yet Pottstown was just that. After a week of working hard, people yearned to relax, be entertained, and pursue pastimes that lifted their spirits and enlightened their minds. They also had money in their pockets, allowing them to sustain a lively arts scene. And because Pottstown was the largest town between Norristown and Reading, people from the borough as well as the neighboring countryside headed here to reward themselves with a night out on the town, either seeing a movie at the Strand or the Hippodrome, attending the symphony, or hearing the Pottstown Band playing in Memorial Park on a summer night.

Residents and visitors also took advantage of the concentration of arts-related businesses, from musical instruction to photography studios. It should come as no surprise, then, that highly skilled actors and musicians would emerge from such a vibrant cultural scene and make a name for themselves beyond Pottstown's borders. This chapter provides a sampling of these creators of the arts and cultural scene from the past as well as those currently pursuing their artistic dreams and taking a chance on making a living at it in Pottstown.

Worthy of mention are the numerous photographers present in Pottstown at the end of the 19th century and beginning of the 20th century who were practitioners of the art of the *carte de visite*, or CDVs, which were so popular at the time. The CDV was a small albumen print on thin paper and mounted on a thicker paper or cardboard, about two and a half by four inches. The method was patented by Andre Adolphe Eugene Disderia, a photographer in Paris, France, in 1854. When he published a CDV of Napoleon in 1859, the practice became popular worldwide. Not only did people get their own photograph taken, they would also collect CDVs of famous people and keep them in albums in their parlors. Eventually, "cardomania" arrived in Pottstown, too. Although images of the photographers themselves are hard to come by (and thus they are not shown here), the works of Isaac S. Lachman, Richard Somiesky, Thomas Taylor, and A.J. Andre, depicting people of all ages and all walks of life from southeastern Pennsylvania, survive to this day.

Jazz Master

Al Grey (1925–2000) possessed one of the most recognizable trombone-solo styles during a career that spanned six decades and included stints with some of the greatest jazz orchestras. Born in Aldie, Virginia, Grey moved with his family to Pottstown when he was three months old, settling first at 164 Grant Street and later at 26 Cottage Row. His father, Richard, worked in a steel plant but was also an accomplished musician who guided his son's early music education. At age four, the youngster played baritone horn in the Goodwill Boys' Band, which his father led. Al eventually switched to tuba, which he played in the Pottstown High School (PHS) marching and dance bands. The high school band director was a trombonist, and that was when Al was first captivated by its sound.

Grey enlisted in the Navy in 1942 and was sent to the Great Lakes Training Center, where many noted musicians were stationed. Because the tuba was no longer in vogue, in order to play in the Navy dance band, Grey turned to the trombone and quickly developed into a skilled ensemble player and an accomplished improviser. After his discharge in 1945, bandleader Benny Carter hired Grey on the spot. With Carter, the trombonist made his first recordings. Even at that early stage, Grey had perfected the swaggering, outgoing solo style for which he would become famous. He would become a master of the plunger-muted, "vocal" technique, which he could apply with equal effectiveness to both blues and melodic-ballad interpretations. On open horn, Grey was also fluent in the virtuoso, rapid-fire, bebop idiom.

Grey played with the bands of Jimmy Lunceford, Lucky Millinder, and Lionel Hampton. He once recalled the difficult traveling conditions for black bands in the South during the postwar years, saying, "we couldn't go into restaurants and have a meal . . . we couldn't go into none of the hotels . . . so we would get off the bus and scour around that town to see where we could get a room." In 1957, Grey joined the Count Basie orchestra. Nicknamed "Fab" by Basie, as featured soloist, Grey became an internationally known jazz star. Afterwards, he led his own groups, toured with all-stars, recorded extensively, and became a fixture at jazz festivals worldwide. Current trombone star Wycliffe Gordon, mentored by Grey, remembers this advice: "Always make them announce your name!" Despite his fame, Grey continued to return home between gigs and live in Pottstown. (Photograph and text courtesy of Ed Berger.)

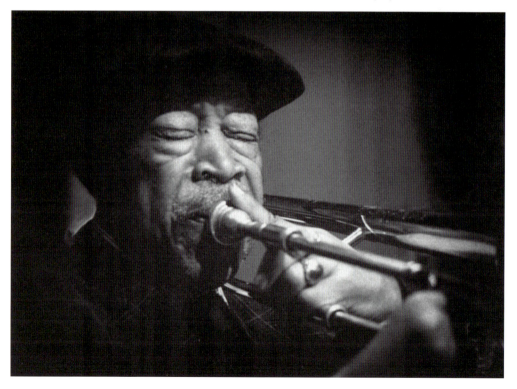

A Musical and Civic Legacy

When William F. Lamb Sr. passed away in Pottstown in May 1962 at the age of 83, he left an artistic legacy that would influence the musical landscape of the region for generations to come. As director of the Pottstown Band from 1928 to 1936 and as the founder and operator of Lamb's Music House from 1901 to 1947, he provided training, musical instruments, Victrolas, and records to aspiring musicians and families interested in enriching their homes with music. At the end of World War II, some 325 students were taking music lessons there. As reported in the *Reading Eagle*, what may be forgotten is that Lamb was also president of the Pottstown Automobile Club for 30 years and served as a Republican councilman from the eighth ward from 1947 to 1951. He was also instrumental in the residential development of the North End. (Both, courtesy of Pottstown Historical Society.)

A Life in Tune

William F. Lamb Jr. was born in 1915 and had established himself as a gifted cornetist by the time he was 12, performing in Atlantic City and Philadelphia. During World War II, he played solo trumpet for the US Military Band. In 1948, he married Margaretta Reid, and their life together was a long-running melody. Lamb founded the Pottstown Symphony Orchestra in 1964; it was comprised of regional professional musicians and talented local students, all of whom practiced and performed as unpaid volunteers. It provided a stepping-stone for students who wanted to pursue music in college. In 1968, Lamb became the head of the music department at Pottstown High School. These pursuits would be his professional obsession until his death in 1982. Eidam Porter, who had been principal clarinetist with the orchestra since 1968, took over as conductor. (Both, courtesy of Kathy Lamb Williams.)

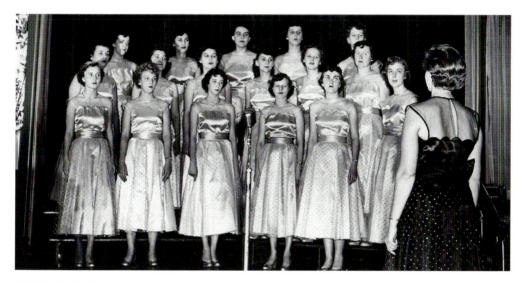

A Melody Maid

Margaretta "Peg" Reid Lamb has been instrumental in the education of countless vocalists and musicians in the Pottstown region since the mid-20th century. The Margaretta R. Lamb Music Scholarship given by the Boyertown Area Choral Association, which she conducted for many years, continues to support students studying music in college. As the founder and director of the Melody Maids (above), and as founder of Peggy Reid & Her All-Girl Band (below) in 1945, she already had a musical career when she and William F. Lamb Jr. married in 1948. Together, they ran Lamb's Music House at 247 East High Street, which Bill had taken over from his father. She was also the principal string bass player of the Pottstown Symphony Orchestra. Except for time spent raising a family, Peg enjoyed a career teaching music in the Pottstown, Pottsgrove, and Boyertown school districts. (Above, courtesy of Kathy Lamb Williams; below, courtesy of Margaretta Reid Lamb.)

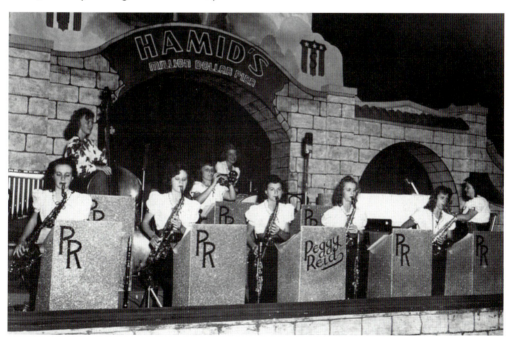

Strike Up The Band
Dr. Myra Forrest joined the Pottstown Symphony Orchestra Board of Trustees in 1984. After serving as vice president from 1985 to 1986, she was president for 17 years. Under her leadership—especially in fundraising—the orchestra became a fully paid, professional orchestra with a budget of about $500,000, in 2005. Doctor Forrest was the superintendent of the Owen J. Roberts School district from 2005 to 2009 and has worked in the Pottstown School District in many capacities. (Courtesy of Dr. Myra Forrest.)

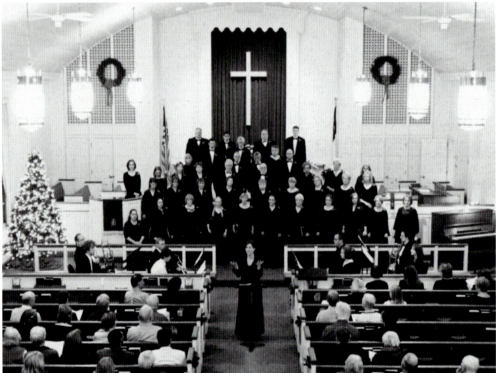

They Sang for Joy
In 1972, Joe Hoover was teaching third grade when someone got wind of his musical education and asked if he wanted to start a chorus. He soon found himself the director of the Coventry Singers, and he did not put down the baton until 22 years later, when he was followed by directors Cheryl Markofski and Julie Eurillo. The group, which gives free Christmas and spring concerts, celebrated its 40th anniversary in 2012. (Courtesy of Coventry Singers.)

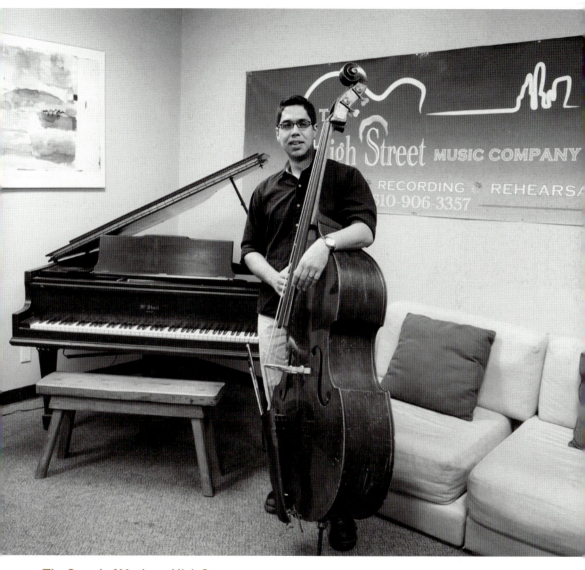

The Sound of Music on High Street
The founding of the High Street Music Company came about like a phoenix rising from the ashes. In November 2006, the doors of Phoenix Studios on Lewis Road in Limerick suddenly closed, and Louis Rieger, a music teacher there, made a quick decision to try to get some of the other teachers and 120 students to join him in a new venture. Within a couple of months, he was a business owner in Pottstown with a five-year lease at 135 East High Street. The primary mission of the High Street Music Company is "to preserve the integrity and prosperity of cultural arts within our community and raise awareness of their social and educational importance." Rieger is the front man for the High Street Swing Company, which has played to sold-out audiences at ArtFusion 19464. (Photograph by Ed Berger.)

Swing It!
Faryl Codispoti has been running Swing Kat Entertainment at the old Eagles Lodge at 310 East High Street since 2006. Starting out with live swing-band dances, he has added classes for swing, ballroom, salsa, and Zumba. In 2011, he incorporated the Ballroom on High, LLC, for private party rentals. "It's always been my dream to have a dance place near home," said Faryl, shown here with his wife, Bijal. (Photograph by Impressions Media Design.)

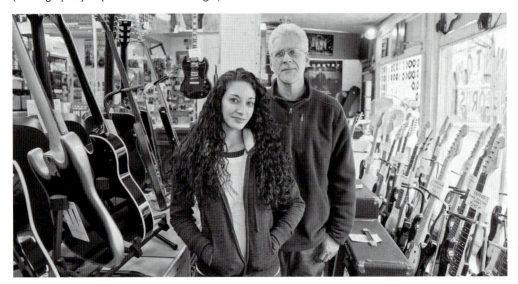

Listenin' to the Music
In 1971, with $300, Galen Royer Jr. opened Downtown Records at 51 North Charlotte Street, a few doors from his father's business, Royer Optical. Now, he also buys and sells equipment out of Ben's Music. His mother came to work there every day for 40 years. "People respected her," says Royer, shown here with Stacy Ludy. "There was this Hell's Angel who'd come in and kiss her on the hand." (Photograph by Ed Berger.)

Sparking Creativity, Building Self-Confidence

In 2004, when Erika Hornburg-Cooper and Cathy Paretti founded the Gallery School and the Gallery on High, respectively, they envisioned a renaissance of the arts in downtown Pottstown and paved the way for those to follow. They began teaching students of all ages and showcasing the work of local and nationally known artists in what is now a fully renovated Victorian structure at 254 East High Street in the heart of the business district. Hornburg-Cooper (left) is proud that they have kept their doors open. "Nonprofits are constantly battling for funds necessary for program development and community participation," she said. In 2012, they rebranded under the name ArtFusion 19464. Their highly successful 2012 exhibit, Threads of a Story: Continued, featured the work of Charlotta Janssen and highlighted the civil rights movement and Freedom Riders, using art to relate history and tell a story. (Above, courtesy of ArtFusion 19464; left, photograph by Ed Berger.)

Supporting the Artistic Spirit

The Pottstown Area Artists' Guild, founded in 1960, has progressed from hanging art on clotheslines strung between High Street parking meters to Art on The Hill—The Pottstown Art Show, held each spring at the Hill School Center for the Arts. The late Stanley Boyer was a longtime member and a world traveler, visiting every continent except Antarctica. He brought home a piece of artwork from every country he visited. (Courtesy of David Manak.)

The Girl with the Grecian Face

Silent screen actress Naomi Weston Childers was born in Pottstown in 1892; the 1900 US census shows that she was adopted by John and Nora Childers. Raised in St. Louis, she took up acting as a young child. Her film career began with *Panic Days in Wall Street* in 1913 and included nearly 60 films. She was once voted the most beautiful woman in Japan. She died in Hollywood in 1964. (Author's collection.)

Where the Play's the Thing

In the wake of September 11, 2001, Marta Rubin Kiesling (left), an attorney and human resources consultant, and Deborah Stimson-Snow, a director of music with extensive production experience, decided to take the leap and create a performing arts company that would nurture and showcase the restorative power of art.

In 2008, recognizing the potential to contribute to downtown Pottstown's revitalization, Kiesling and Stimson-Snow opened a theater at 245 East High Street in the former J.J. Newberry Department Store with its original hardwood floors, brick-and-cement walls, raw-wood joists, and exposed I-beams stamped "Bethlehem Steel." In 2012, they unveiled a flowing steel mesh facade and high-technology marquee while announcing their new, permanent name: Steel River Playhouse.

The award-winning Stimson-Snow, with a bachelor of arts in music from the University of Washington and a master's degree in music from the University of Massachusetts at Amherst, is the artistic director at Steel River. She has extensive experience in opera, oration, choir, and musical theater, and has been director of music for the Unitarian Universalist Church of Delaware County, director of music for the Media Chamber Chorale, and professor of music appreciation and piano at the University of the Sciences in Philadelphia.

In addition to holding a law degree, Kiesling is also a performer. Her production credits include *The Mikado*, *The Secret Garden*, *Sweeney Todd*, and many others. She has played Mabel in *The Pirates of Penzance*, Adelaide in *Guys and Dolls*, and Eliza in *My Fair Lady*, among many other performances that include cabarets, education workshops, and concerts.

Steel River Playhouse seeks to strengthen community, inspire, educate, and entertain. Kiesling and Stimson-Snow see Steel River as part of a growing number of performing arts organizations that are creating a new paradigm for American theater in their promotion of individual, audience, and community development through performing arts education and events. Stimson-Snow best summed it up at a "State of the Organization" gathering in 2010, saying, "There's a kind of truth happening here . . . There's an opportunity every day to do something true." That is what live performance is all about: an artist or group of artists sharing a search for some kind of truth with an audience, which is a noble endeavor. (Photograph by John Daggett.)

Pottstown's Poet Laureate

Ronald C. Downie was a founder of the Carousel and has served on every major governing body in town, including the school board, borough council, water and sewer authority, and Schuylkill River Greenway. In recent years, he has solidified his position as Pottstown's poet laureate through his blog, The Posted Poet.

About 40 years ago, Downie spent a lot of time going between landscaping crews alone in a pickup truck. At different times, certain phrases, sentences, or couplets would come into his mind and he'd find himself repeating or memorizing them. From them he tried to create poems that had resonance—resonance in a pickup truck with the windows up.

"I'm not a learned poet," he says. "I just came about it by osmosis." His dad had *Harper's* and *Atlantic Monthly* around the house, and he never knew at the time that he was reading poetry or stories that were written well.

Later, the work of the poet Walt Whitman affected him a great deal. Much of it told of the woes of the human experience, but it got his attention through the sound of it, not necessarily the theme. He still tries to write with the rhythm of a 10-beat line that gives the words a cadence that pleases him. His signature poem is called "Song Tune," in which he writes of "the song of life" and the tune that is "ours, ours, all alone to find."

"We are part and parcel of this whole big thing called life," he says. "There's a bomb going off in the Atolls, or a crash on Charlotte Street, and all our speech, and this I define as the song of life. But there is this restriction that puts this into context, and that is the idea of time. And there is one lasting thing that is pertinent only to ourselves and that is our tune. Everyone has an individual tune that expresses the sum total of their being." (Photograph by Ed Berger.)

CHAPTER SIX

Culinary Artists

It is notoriously difficult to survive in the restaurant business, or in any kind of commercial endeavor that brings food to the kitchen table, but that has not stopped generations of Pottstown natives from taking risks and succeeding with mouth-watering results. Pottstown's most famous culinary artist and entrepreneur was, of course, Amanda Smith, the woman behind the Mrs. Smith's Pie empire. Beginning in 1919, while she was churning out the pies in her kitchen at home, her son became the distribution and marketing maven who brought those pies to the public, leading to one expansion after another until pies from Pottstown were available worldwide.

As a regional center of employment and commerce, downtown Pottstown was also the place where workers took a lunch break and folks from all around came to have a special meal to mark an anniversary, birthday, or religious milestone. Over time, dozens of restaurants in all price ranges have provided fare for the hungry traveler, tourist, or downtown shopper. These ranged from the Merchants Hotel and the Shuler House (previously the Farmer's Hotel) to the Clover Leaf Restaurant, the Cup, the Very Best, and Dempsey's Diner. Today, Pottstown is experiencing a renaissance in the culinary arts with a new generation of entrepreneurs making their mark not only in traditional heritage eateries and bars but also in new American-, French- and Latin-influenced restaurants emphasizing organic and locally sourced ingredients.

It is important to note, too, that the tradition of delicious, homemade desserts is still being carried on by local bakers, such as Company Cakes and the Milkman Lunch Company & Cake Shoppe. Their traditional and innovative sweet treats are the centerpieces of wedding, birthday, and holiday tables throughout the region as word spreads of their quality and scrumptiousness. Similarly, Schulz's bread, Clover Leaf Dairy's milk and ice cream, and Burdan's ice cream all took their own places in Pottstown homes during the last century. Sadly, for many Pottstown natives over 50 years of age, the longing for Prince's rye bread, the recipe for which is said to be a closely guarded family secret or lost to history, may forever be unfulfilled.

The Stubbornest Woman in All Pottstown (OPPOSITE PAGE)

By the end of World War I, Amanda Smith was a widow who had lost six of her nine children. Her hardscrabble situation, though, did not stop her from baking pies for family and friends in her home on South Street. In 1919, her youngest son, Robert, was 17, still living at home, and had begun to run the lunch counter at the Pottstown YMCA. When he brought his mother's apple pies to sell at the Y, word got out, and they sold out quickly every time. He then got the idea to sell her pies full-time. He took the rumble seat out of his Dodge Coupe and put in a pie cabinet; pretty soon, he was distributing pies to stores in the area. By 1923, they purchased their own store and first commercial oven, and by 1925, Mrs. Smith was no longer actually baking the pies that were being delivered so widely.

A July 1965 *Mercury* article called Amanda Smith the "stubbornest woman in all Pottstown, PA," which seems another way of saying that she had a certain strength of character that did not wither in the face of personal and professional challenges. That article quotes her as saying, "I don't consider money nearly as important as character. Character grows and has value; a business must have character so that it can grow."

In 2009, the Gallery School of Pottstown (now ArtFusion 19464) commissioned local artist Stephen Kent to interpret the history of Mrs. Smith's Pies. The lithograph, entitled *Look for the Rope Edge,* was the first edition in the Pottstown Signature Series. It was done in colored pencil and was sponsored by the Greater Pottstown Foundation in a limited edition of 100 prints. Although the smell of pumpkin pie no longer permeates the town during the early autumn, Pottstown residents can always take pride in this delicious piece of the past. (Poster by Stephen Kent, sponsored by the Greater Pottstown Foundation; courtesy of ArtFusion 19464.)

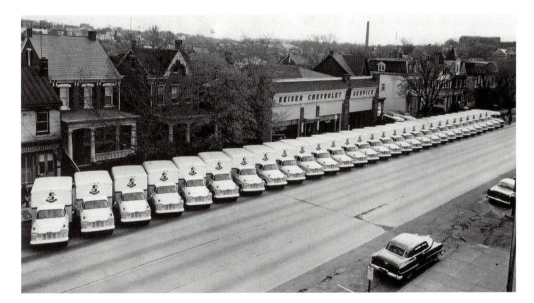

Where the Pie Meets the Road

As the 1920s wound to a close, Mrs. Smith's Delicious Homemade Pies, Inc., would open three more baking plants in Easton, York, and Philadelphia. Eventually, the Smiths had a fleet of panel trucks and drivers reaching much more territory than the horses and carriages had previously been able to cover. The business continued to grow, but it was not until 1950, after six years of perfecting the technique, that the company was able to prepare and ship frozen pies. After that, there was explosive growth, and pies were distributed to every state and numerous military bases outside the continental United States. Sadly (for Pottstown), the company announced in 1976 that it would become part of the Kellogg's Company, and in 2003, the Schwan Food Company bought Mrs. Smith's Bakeries. (Courtesy of Pottstown Historical Society.)

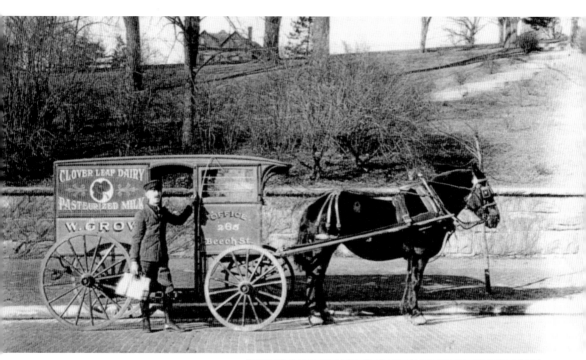

Growing a Family Business

The seeds for Clover Leaf Dairy and Restaurant were planted in 1913 when Wesley and Florence Grow bought two milk routes in Pottstown. Back then, the milk was cooled in ice and dipped directly into the buyer's container. Eventually, the Grows purchased property at 265 Beech Street and across the alley for their home, restaurant, and dairy operation. Upon Wesley's death, Florence and their four sons ran the businesses. Of the four sons, Parker, also known as "Pike," ran the Cup at 903 North Charlotte Street beginning in 1955. His son Perry, shown in 1990 in Neil Fuerman's kitchen, also whipped up cream pies, milkshakes, cheesesteaks, and grilled cheese sandwiches while managing the Cup. One of four cup-shaped structures built by C. Gordon Astheimer in 1942, the restaurant remains an iconic example of mid-20th century roadside architecture. (Above, courtesy of Pottstown Historical Society; right, courtesy of Neil Fuerman.)

Chef About Town

Dominic Viscardi was about 14 years old when he got his first job washing dishes for $8.40 a week at Steckline's at 423 High Street. It was during the war, around 1940 or 1941. He later became a waiter and was eventually introduced to the grill and short-order cooking. He worked there through four different owners—Steckline's, Brown's Grill, Broadway Inn, and the Embassy.

When Viscardi graduated from high school, he and a buddy got a 1940 Chevrolet so they could drive across the country. Their first stop was Florida, but once there, they decided they did not want to see anything else. They stayed all winter, and Viscardi became a professional waiter in Miami, the vacation capital of the world. While there, he made arrangements with the head waiter to work for the summer at the Hotel Champlain in upstate New York, 20 miles from the Canadian border.

By 1949, Viscardi was back in Pottstown, driving a Roth dry-cleaning truck during the day. At night, he was working at Brookside Country Club when "the second cook went on a disappearing act and suddenly I was in charge. Whoa! I was there 9 years." In 1956, George Govatos of the Shuler Hotel passed away. His wife, Mary, revamped the place, preferring the name Shuler Hotel to Shuler House because the latter made it sound like a boardinghouse. She also needed a chef, and Viscardi stayed at the Shuler Hotel for 17 years, until Mary sold it in 1975 to the county redevelopment authority. Mary Ellen Lees, who waited tables, was there on the last day when special menus were printed up and all the employees ate together for the last time.

From the Shuler Hotel, Viscardi landed at Sunnybrook, where he spent the next 17 years. Brookside, the Shuler Hotel, Sunnybrook—it is an impressive resume. "I was pretty well noted for my crab cakes," he said. "And Mrs. Govatos was known for her rice pudding. Later, I was known for my rice pudding." He pointed to the recipe taped to the inside of his kitchen cabinet. "Every week I made a 30-quart pot for the Sunday buffet brunch." Was it the same recipe that Mrs. Govatos used? "No," he said, with a twinkle in his eye. "Mine's better." (Courtesy of Dominic Viscardi.)

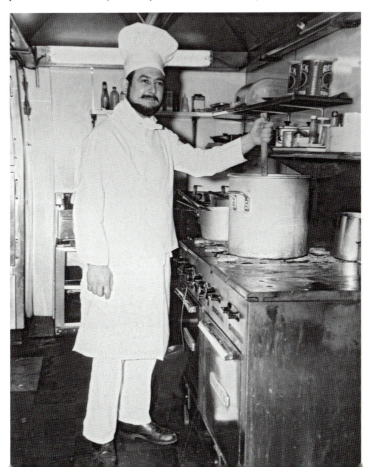

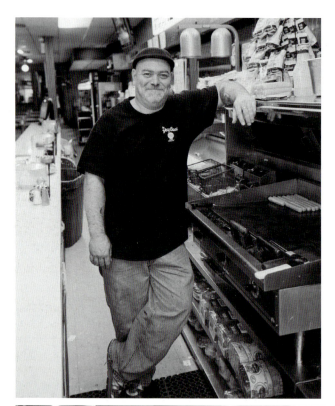

Where Tradition is Carried On
As a kid, Mike Klein's mother and grandmother brought him into the Very Best, the wiener shop and "home of the Everything Dog," which has been in Pottstown since 1921. Now he is the day-to-day runner of the shop, located at 252 East High Street and owned by Amy Shuster and Joe Miller. What does Mike like about coming to work? "The people. The customers. The employees. It's a family atmosphere." (Photograph by Ed Berger.)

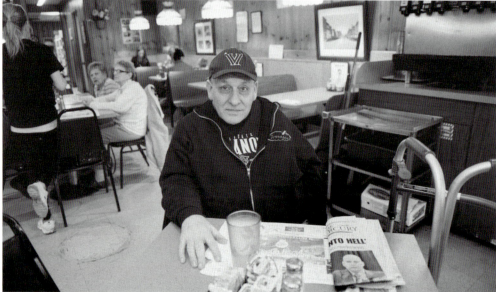

The Very Best Mayor
Most days, Frank Boughter can be found at the center table of the Very Best. Born and raised in Pottstown, his parents used to take him to the restaurant when it was on South Hanover Street. Now known as the "mayor" of the Very Best, Frank says, "It's the best place in town if you're not at home. Food's good. The company's good, and it's been here longer than me." (Photograph by Ed Berger.)

CHAPTER SIX: CULINARY ARTISTS

Fresh and Local
For their second act, Collegeville residents Ben Moscia and Elise LeBoutillier took over the long-standing Pottstown Farmers' Market at 300 East High Street in 2011. Moscia used to work in construction, while LeBoutillier was in seasonal sales to landscaping businesses, a natural fit for someone descended from the founders of Waterloo Gardens. Up until the middle of the last century, the farmers' market used to be in the back of the Bahr Arcade across the street where a parking lot is now located. Today, the historic businesses on the premises include Wegman's Deli & Catering (since about 1968), Mosteller's Seafood (since the late 1960s), and Pottstown Florist (for more than 33 years). Newcomers include Freeland Market & Café and J&H Produce. Pictured, left to right, are Jeremy Mankes (J&H Produce), Kathleen Reifke (Pottstown Florist), Rose Mosteller (Mosteller's Seafood), Donna Hausman (Wegman's Deli & Catering), Ben Moscia, Elise LeBoutillier, and Josh Davis (Freeland Market). (Photographs by Ed Berger.)

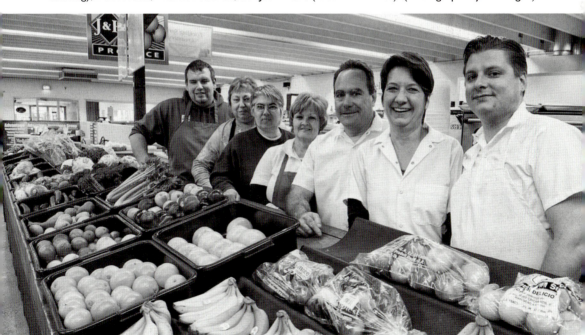

Serving It Up Old School

Brunish's Deli at 577 Lincoln Avenue is not in the Historic Register on National Places, but it has the past written all over it. Even its traditional pork-and-beef hot sausage sandwich with mustard, relish, and onions is called "old school." Brunish's has been a family affair ever since Daniel and Sarah Brunish, the grandparents of current proprietors Dan and Bob Brunish, opened a mini-mart in a basement a few doors away on February 13, 1937. One year later, they moved it to their own basement. Dan and Bob's father took over in 1949, adding hot dogs and hot sausages in 1955. Dan started there at 14; he is now 61. Justin Brunish, Bobby's son, is the fourth generation, and Dan claims theirs is the last originally owned family sandwich shop in town. Even the phone number has always been the same: 326-1900. (Photographs by Ed Berger.)

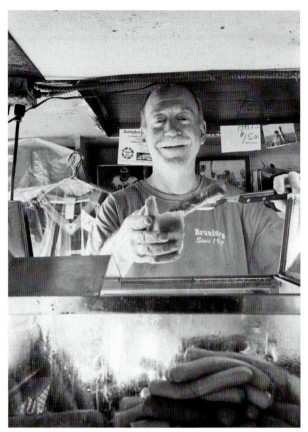

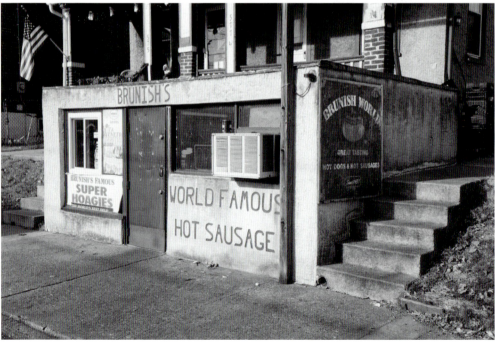

CHAPTER SIX: CULINARY ARTISTS

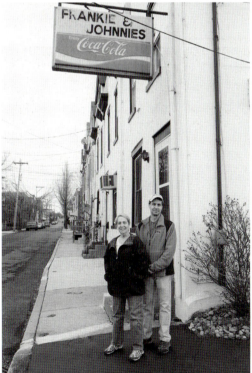

Craig Bolinger and the Ice House
The Ice House at King and Manatawny Streets used to be an actual icehouse. Ray Conway owned it for many years before Craig Bolinger bought it in 1989. Conway's sandwiches and fresh donuts were legendary, and Bolinger is carrying on the tradition. He recently acquired the original donut machine, and churns out the pastries fresh every morning. The only drawback? When they run out, that is it. (Photograph by Ed Berger.)

Where Everybody Knows Your Name
For a real neighborhood bar, look no farther than Frankie & Johnnie's at 214 South Franklin Street. With smoke hanging in the air and sports on television, it is the place to kick back on a Friday afternoon, shoot the breeze, and get philosophical about life. The mother-son duo of Carolyn and Jim Iezzi has been running the place since 1988. Who were Frankie and Johnnie? They do not know. (Photograph by Ed Berger.)

Sandwich Satisfaction
Gene Dugan opened Grumpy's in 2010; two years later, he expanded to a new location at 137 East High Street. Even though Gene is "Grumpy" (the name came from one of his five children), his hearty soups and sandwiches make people happy. "I try to remember what my customers want. They make my business. Sometimes it's like Mayberry RFD in here," he quips. "That's how I want to keep it." (Photograph by Ed Berger.)

How Sweet It Is
Mark Neiman and Nancy Ackerman have been keeping things sweet at 26 North Charlotte Street since opening Company Cakes in 2001. With Nancy's stash of family recipes, they finally took the plunge and started their own business. "We're a scratch baker, independently owned," says Mark. Their best sellers are dessert and coffee cakes and pies; they do a brisk wholesale business with area restaurants. Their sticky buns defy description. (Photograph by Ed Berger.)

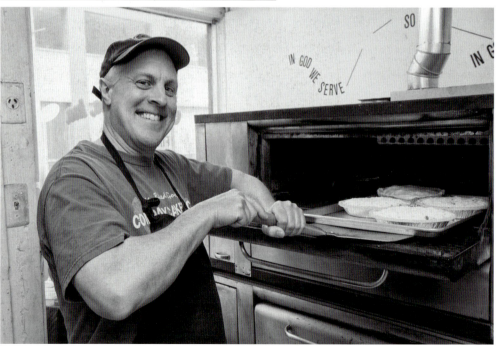

CHAPTER SIX: CULINARY ARTISTS

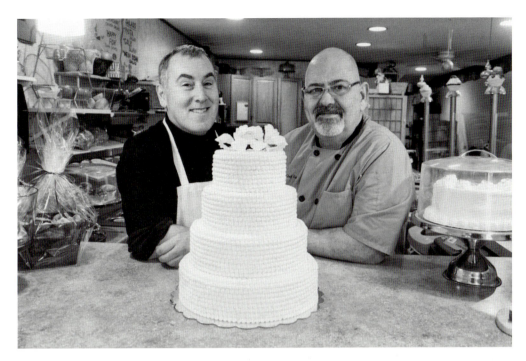

Love, Hope, and Happiness through Cake
With their ever-changing display of fabulously flavorful cupcakes and tasty soups and sandwiches, Chris Longeway (left) and Sam Rhame of the Milkman Lunch Company & Cake Shoppe are part of a new wave of culinary artisans. Their original shop at 451 North Charlotte Street was home to Mayer's Bakery back in the day. In August 2013, they moved to expanded digs at 250 East High Street. Their wedding cakes are truly works of art—and eminently edible, too. (Photograph by Ed Berger.)

"Scrumptious, Inspired Buffets"
Two sisters plus two degrees from the Culinary Institute of America equals great food and parties for the Delaware Valley. Starting out at the Pottstown Farmers' Market in 1989, Amy Bause-Bartra (left) and Erin Bause have grown Bause Catered Events into a regional-award winner. As members of the family behind the well-known Bause's Drug Store and Pottstown Copy Fast, they are carrying on a long family tradition of business investment in the borough. (Courtesy of Dave Bause.)

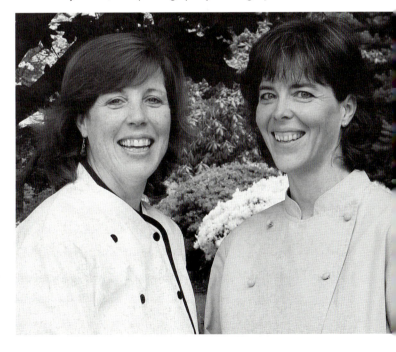

LEGENDARY LOCALS

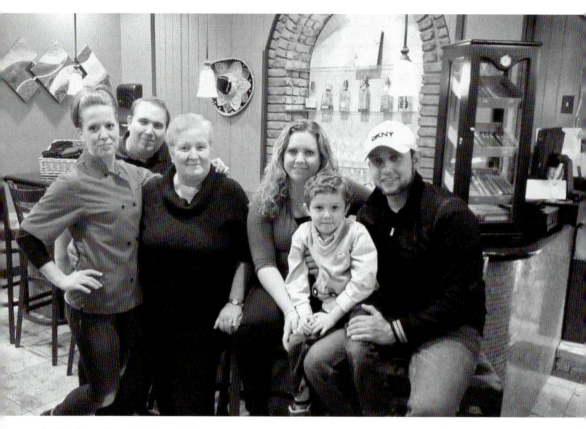

Latin American Melting Pot
The former Boyer's Shoe Store at the corner of High and Penn Streets has been transformed into the very chic Juan Carlos Fine Mexican Cuisine. Chef Ron Garza knew the location was right when he saw the interior stone walls, the brick-arched windows, and the cobblestone road running up Penn Street in 2009. "I wanted a place with a real urban feel, not a shopping center," he said. The menu could be described as authentic Mexican with a South American flair that includes elements of modern Mexican cuisine. Mexico is a melting pot of numerous Latin American cultures, and Garza incorporates dishes and flavors from Brazil, Argentina, and Cuba. Team Garza includes, from left to right, Lauren Ralston, Stavros Stratis, Many Stratis, Jeanne Stratis-Garza, Stamos Garza, and Ron Garza. (Courtesy of Jeanne Stratis-Garza.)

Big-City Dining (OPPOSITE PAGE)
In 2004, chef Michael Falcone bought the former Pat's Luncheonette at 232 King Street and, with Tonda Woodling, reinvented it as Funky Lil' Kitchen, an eclectic American bistro serving fresh, seasonal, organic dinners. Even with a *Zagat* rating of 27 out of 30, Falcone is increasing his business's flexibility by investing in a food truck in 2013. "Same cooking," he says, "just scaled down." (Photograph by Ed Berger.)

CHAPTER SIX: CULINARY ARTISTS

The Brick House
There were probably a few skeptics when Dave and Blair Walsh opened the Brick House in 2007 in the former Security Trust Bank in the heart of downtown. Six years later, with more than 50 employees, it is the go-to place for a burger, Ahi tuna wrap, or dancing on a Saturday night. "I cruised High Street for years," says Dave. "We wanted people to see that Pottstown *is* the center of everything." (Photograph by Ed Berger.)

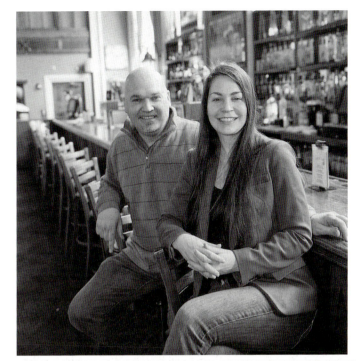

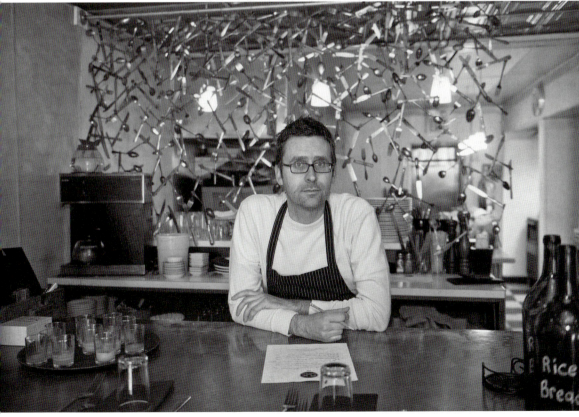

What's in a Name?
People may wonder why Henry's Café at 20 South Charlotte Street is run by a chef named Frank. The answer is simple: Frank Raski reads a lot, and he likes the American short story writer William Sydney Porter—better known as O. Henry—who died a penniless alcoholic on June 5, 1910. While O. Henry had a way with words, Raski is an artist with food, especially fresh fish. He acknowledges Jean Francois Taquet as the one who taught him discipline and how to be a chef while Larbi Dahrouch showed him how to be creative when they were all at Restaurant Taquet in Wayne, Pennsylvania. And, for six months, Clark Gilbert was his mentor. "When you're new, you always need someone looking out for you in the kitchen, and that's what Clark did for me," he said. Raski is shown here with Denise Gaugler. (Photographs by Ed Berger.)

CHAPTER SEVEN

Sports Standouts

If one wants to go down in sports history in Pottstown, it is good to have a nickname: Buck, Mush, Chuz, Chump, or Peachie. Yogi will do, too, as in Earl "Yogi" Strom, the colorful NBA referee who wrote *Calling the Shots: My Five Decades in the NBA*. His control of the game with his whistle earned him the moniker "the Pied Piper," and he is in the Naismith Memorial Basketball Hall of Fame.

Pottstown has got to be one of the greatest producers of outstanding athletes and coaches per capita of any small town in America, and it may have the best nicknames, too. There are way too many success stories to fit into this chapter. Pottstown High School, the Hill School, and St. Pius X have all sent numerous athletes on to major college teams, professional leagues, and Olympic teams. St. Pius X, which operated just across the border on North Keim Street in Lower Pottsgrove Township from 1955 until 2010, is included here because much of its student body came from its Pottstown feeder parishes of St. Aloysius and St. Peter's.

It is impossible to pinpoint any specific era as the heyday of Pottstown athletics. The values that made for successful athletes throughout the 20th century and into the 21st—hard work, the drive to succeed, and pride in oneself and one's community—are the same qualities that were exhibited by Pottstown's founders. Those traits can still be found today on the courts, tracks, and playing fields of Pottstown.

This chapter takes readers on a whirlwind tour of some of the better-known sports legends. Early on, they were mostly male, but with the 1972 passage of Title IX—the federal civil rights law that bars gender discrimination in any educational program that receives federal funding—many new athletic opportunities opened up to girls and women. As with the male athletes, it is only possible to cherry-pick from among the many female athletes from Pottstown who have distinguished themselves in competition.

In addition to the names and faces that follow, some of the more prominent athletes of the modern era that deserve mention include Aaron Beasley and Rian Wallace, both professional football players; Jane Geyer, an attacker on the women's lacrosse team at Kutztown University from 1982 to 1984 (during which time she amassed 127 goals and was named All-American for two consecutive years); and Seth Ecker, the first two-time NCAA national-champion wrestler from Ithaca College. More recently, Quiana McIntosh has become a hurdler and runner for Pottstown High to watch, having established a reputation in the PAC-10 league and in district and state competition. Additionally, a St. Pius X graduate and one of the Pottstown Roller Derby Rockstars founders, Lida Addison, is staking her claim to new territory. The Rockstars have brought the energy, excitement, and fast pace of professional roller derby to Pottstown. With between 300 and 500 people attending each bout in their 2012 inaugural season at the 422 Sportsplex, they are already making history. Nothing less is to be expected from a woman whose derby nickname is "Low-Blow Lida."

An Error of Omission
George "Buck" Weaver, shortstop and third baseman for the Chicago White Sox from 1912 to 1920, was banned from major-league baseball for his role in the 1919 Black Sox scandal. His error: failing to report that his teammates would throw the World Series. He batted .324 in the losing effort. Although acquitted by a jury, the commissioner banned him for life; he fought his entire life for reinstatement, to no avail. (Author's collection.)

World Series Champion
He was not a big man, but Bobby Shantz could throw a baseball. At five foot six inches tall and 139 pounds, he was a left-handed, major-league pitcher from 1949 to 1964. In 1952, he was the runaway favorite for the Most Valuable Player of the American League with a record of 24-7 with the Philadelphia Athletics. An eight-time Golden Glove Award winner, he won a World Series ring in 1958 with the New York Yankees. (Author's collection.)

Leaping Tall Buildings in a Single Bound

Born in 1904, Sabin Carr came to the Hill from Dubuque, Iowa, graduating in 1924. During his subsequent career at Yale, he continued to improve in the pole vault, clearing 13 feet 7 inches in 1928, setting a new Olympic record and winning gold in Amsterdam. Perhaps more remarkable was when he cleared 14 feet in competition the year before, which no one had ever done until that time. (Courtesy of the Hill School.)

"Do It Right or Not at All"

The late Carroll "Mush" Bechtel Jr., a four-year basketball and tennis player at Pottstown High School, was inducted into the Tri-County Area Chapter of the Pennsylvania Sports Hall of Fame in 2004. He and his family operated the legendary Bechtel's Sporting Goods downtown for more than 50 years. Bechtel carried on his father's motto: "Do it right or not at all." He is shown here (wearing the fedora) with the 1930–1931 Pottstown High School team. (Courtesy of Dave Reidenouer.)

1930-31

1ST Row - W. HETTRICK, T. VASIL, L. DeZURA, C. GUSS, S. GRUBB
L. STROM, W. GROVE, H. LEH, R. WARNER, T. BOLOGNESE
2ND Row - P. BOWER, L. BACHMAN, R. RICKETTS, E. PENNYPACKER
F. ROYER, T. LAWLER, Coach "MUSH" BECHTEL, E. LORD

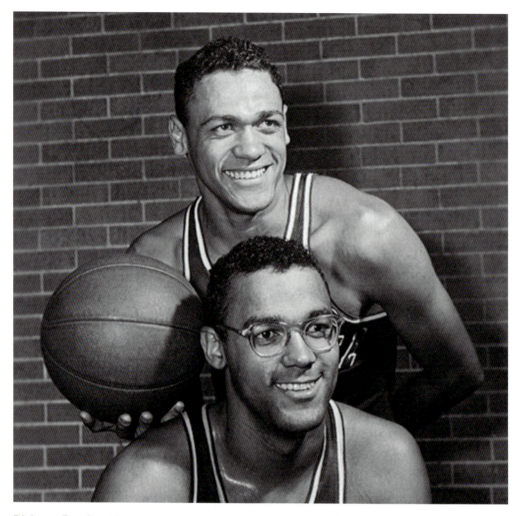

Ricketts Brothers Reign Supreme
Pottstown-born and -raised, Richard J. Ricketts Jr. (top) and David Ricketts, known respectively as "Dick" and "Dave," were members of the Pottstown High baseball team that won 48 straight games, setting a national record and earning them recognition in the National Baseball Hall of Fame. They played basketball together at Duquesne University in Pittsburgh and both went on to professional careers—Dick, in basketball and baseball; Dave, in baseball as a player and coach.

At 6 foot 7 inches tall, Dick played forward for Duquesne University and was the No. 1 NBA draft pick in 1955, going to the St. Louis Hawks. He played three seasons with the Hawks and the Rochester and Cincinnati Royals. He averaged 9.3 points, 6.3 rebounds, and 2.1 assists per game in his 212-game career. Dick was also signed as a free-agent pitcher by the St. Louis Cardinals in 1955. When a tragic injury to one of his teammates caused him to retire from the NBA, he pitched one season for the Cardinals.

His brother Dave, a catcher and bullpen coach for the St. Louis Cardinals and the Pittsburgh Pirates from the 1950s until 1991, got to know what it was like to win the World Series in both capacities. He was a reserve catcher on the 1967 championship Cardinal team, a bullpen coach during their 1982 World Series championship, and a bullpen coach for the Pirates during their 1971 World Series win. Evidently, the apple did not fall far from the tree. Their father, Richard J. Ricketts Sr., is shown on page 89 in the photograph of the 1930–1931 Pottstown High School basketball team. (Courtesy of Duquesne University Athletics.)

On the Wings of Victory
In the late 1960s, Bob "Chuz" Calvario and Al Cavallo teamed with local underwear magnate Ed Gruber to bring an Atlantic Coast Football League (ACFL) team to Pottstown. Philadelphia native and former Eagle Dave DiFillipo, shown here, signed on to coach the Pottstown Firebirds. Made up of wannabe professional players, the Firebirds won the ACFL title in 1969 and 1970 and were widely considered the best team in the country. (Courtesy of John Katch.)

Firebird Flying High
Defensive tackle Bill Stetz bounced around before landing with the Pottstown Firebirds. As he made the rounds of professional tryouts, his signature long hair stood out. Between that and his bell-bottoms, he may have lost out on a contract. He ran Middle Earth, a subterranean shop at 20 South Hanover Street that carried leather belts and hash pipes; his wife ran a similar shop in St. Peter's Village. (Courtesy of John Katch.)

Monday Morning Quarterback
From 1973 to 1975, Dave Reidenouer played quarterback and defensive safety for Pottstown High and was named First Team All-State at safety. He played four years at linebacker at Bloomsburg and did a 20-year stint as the Monday-morning quarterback on PCTV. In 1999, Reidenouer was inducted into the Tri-County Area Chapter of the Pennsylvania Sports Hall of Fame. He is shown here with tailback Lovey Jones (No. 46). (Courtesy of Dave Reidenouer.)

Talking Sports with Seeley
For more than three decades, sports writer and editor Don Seeley covered area sports in the *Mercury*. He was widely respected for his in-depth coverage of high school wrestling. While his award-winning writing touched the lives of the thousands of young athletes whose triumphs he chronicled, he himself also beat the odds, surviving throat cancer. Seeley passed away June 26, 2013, at the age of 62, while playing golf, a game he loved. (Photograph by John Strickler.)

A Voice to Remember

For more than 50 years, Elmer "Chump" Pollock announced the football and basketball games at Pottstown High. He was a founder of the Tri-County Area Sports Hall of Fame and a vice president of the Pennsylvania Sports Hall of Fame. He also flew with the "Snoopers" 868th Bombardment Squadron—low level, antishipping radar night bombers—in the South Pacific. Back home, he worked at Bethlehem Steel for 40 years. (Courtesy of Mark Pollock.)

A Winged Lion Always

Jim Mich became the head football coach at St. Pius X in 1959 and stayed until the school closed 51 years later in 2010. He spent 26 years as the head coach, ending with a 159-89-11 record and a stadium named after him. He also put in 28 years as athletic director, along with other teaching and administrative duties. "It was a great place with great kids," he said. (Courtesy of Jim Mich.)

LEGENDARY LOCALS

Taking It to the Hoop
Sisters Kathy Glutz (above) and Carol Glutz McFadden dominated the hardwood at St. Pius X (SPX), then contributed mightily to a budding women's basketball dynasty at Rutgers University. Kathy (SPX class of 1976) was the first woman to score 1,000 points for the Scarlet Knights, setting scoring and rebounding records. Carol (SPX class of 1980) set a SPX school scoring record (1,621 points), captained Rutgers for two seasons, and won an Association for Intercollegiate Athletics for Women (AIAW) national championship in 1982. (Above, courtesy of Kathy Glutz; right, courtesy of Carol Glutz Mcfadden.)

Just Peachie

Stephanie "Peachie" Nixon earned 12 varsity letters and was All Ches-Mont League an astonishing eight times before graduating from Pottstown High in 1981. She was the first female basketball player at the school to reach the 1,000-point mark, and she led the Trojans to Ches-Mont League and District 1-AAA titles. She was named to the Tri-County Area Chapter of the Pennsylvania Sports Hall of Fame in 2004. (Courtesy of Pottstown School District.)

From Trojanette to Marauder

Darlene Newman was a starting forward for Millersville University from 1979 to 1983 and a three-time All-PSAC Eastern Division honoree. She totaled 1,305 points, averaging 14.8 points per game, and her career scoring average is a program record. An all-around athlete, Newman was also a member of the 1982 women's lacrosse AIAW National Championship team. She has been an assistant basketball coach at Millersville for the past 19 years. (Courtesy of Millersville Athletics Communications.)

LEGENDARY LOCALS

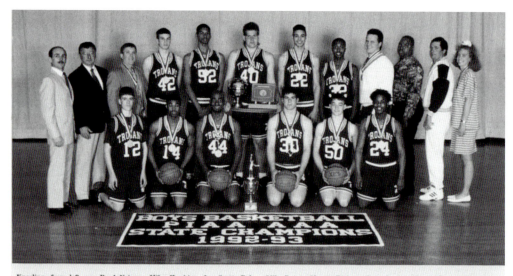

Kneeling, from left, are Brad Neiman, Mike Hawkins, Jay Scott, Bob Stumpf, Mickey Yonas and David Charles. Standing, from left, are athletic director John Armato, principal Anthony Zampella, head coach Ken Davis, Mike Perate, Marcus Ricketts, Dave Auman, Howard Brown, Tom Harvey, assistant coach John Iswalt, statistician Todd Wallace, assistant coach Dave Bennett and scorekeeper Tricia Mace.

State Champions

When receiving recognition for the success of his varsity boys' basketball teams at Pottstown High from 1980 to 1997, legendary coach Ken Davis has been known to credit his players for their hard work, discipline, and unselfishness. They won six district titles and the PIAA-Class AAA state title in 1993. Davis himself played ball and graduated from Pottstown in 1962, though he was, in his own words, "lousy." (Courtesy of Dave Reidenouer.)

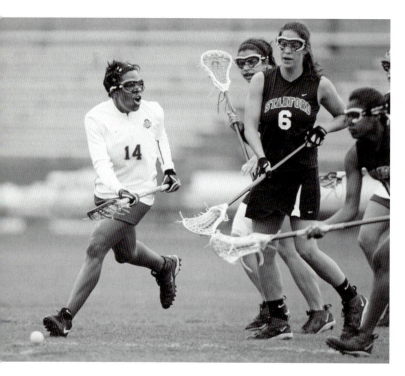

All-World Role Model

Pottstown graduate Gina Oliver was a three-time All-American and one of the best lacrosse players Ohio State University has ever seen, competing for the Buckeyes from 2002 to 2005. She played on the US women's national team that won the 2009 World Cup and was named to the All-World Team. In 2012, after stints as assistant coach at Ohio State and Duquesne Universities, she became the head women's lacrosse coach at the University of Cincinnati. (Courtesy of Ohio State Athletics.)

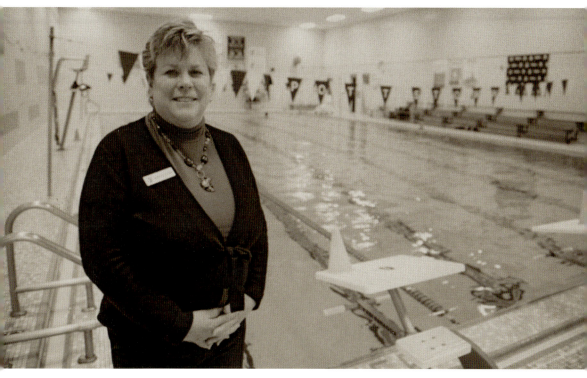

Keeping a Swimming Tradition Alive

Kathy (Detar) Cook, the longtime YMCA swim coach, has been teaching swimming for 43 years. "It's been more like a calling," she said, "Like God wants me to be here teaching kids to swim. Teaching them a life skill. It gives them confidence in life."

She herself learned to swim when she was just a couple of years old and was competing by the time she was eight at the East Greenville pool. When her family moved back to Pottstown, she swam at the YMCA on King Street and became a three-time YMCA state champion in butterfly and freestyle back in the 1960s. At Pottstown High she played lacrosse and was a cheerleader, but when she went to college at East Stroudsburg State, her cheerleading career came to an abrupt halt. The cheerleading coach was also the swim coach, and when she heard some of Cook's times, she said, "You're not going out for cheerleading." Cook ended up playing varsity lacrosse and swimming, becoming cocaptain of the swim team her junior year.

She started teaching swimming at the North End Swim Club and at the old YMCA when she was 16 years old. Since 1999, she has worked full-time at the YMCA in Pottstown. That was also the year the Y began providing swim lessons to every third grader in the Pottstown School District. More than 3,000 children have had exposure to swimming and water safety since then.

Of her many students who have gone on to swim in college, perhaps the one who stands out the most is Patrick Schirk. Cook met Schirk at the North End when he was about five years old. By the time he was 14, he was breaking national records in the backstroke. He became an 11-time YMCA national champion and was the 2005 Pennsylvania state champion in the 100-meter backstroke. At Penn State, he was a two-time All-American and the first-ever individual NCAA champion in men's or women's swimming when he won the 200-meter backstroke in 2008 with a time of 1:40.22.

Cook is quick to say she has enjoyed teaching and coaching all her swimmers. She can also rattle off a long list of accomplished swimmers and coaches from Pottstown, including Jill and Jenis Bechtel, Mush Bechtel, Woody Kirlin, Judy Levengood, Hal Begel, Todd Ellis, and Frank Elliott. The list goes on and on. "I've tried to keep the tradition of good swimming in Pottstown going," she said. (Photograph by Ed Berger.)

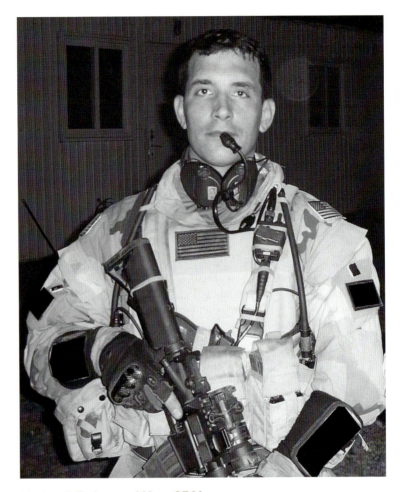

Son, Brother, Husband, Father, and Navy SEAL

Comdr. Job Price lost his life while supporting stability operations in central Afghanistan's Urozgan Province on December 22, 2012, at the age of 42. He had been a naval officer since 1993. He is survived by his wife, Stephanie; daughter Jillian; and his parents, Harry and Nancy Price.

At Pottstown High School, Price was a member of the National Honor Society and graduated No. 3 in his class. He was also a standout on the football field and the wrestling mat, contributing to PAC-10 titles for PHS in both sports as a senior. Among his many titles and accolades in football were PAC-10 First Team offense and defense, All-Area first team offense and defense, Suburban First Team offense, PCTV Defensive Player of the Year, and PAC-10 Defensive Player of the Year. In wrestling, he was Spring-Ford Tournament Heavyweight Champion, Coatesville Tournament Champion, Sectional Champion; District Champion; and PAC-10 Second Team Heavyweight.

Following high school, Price attended the US Air Force Academy and earned a degree in human behavior and leadership. He held the rank of commander in the prestigious Navy SEALs. Price had received two Bronze Stars, three Defense Meritorious Service Medals, the Joint Service Achievement Medal, three Navy Commendation Medals, and two Navy Achievement Medals. He was also a graduate of the US Army Rangers School.

John Armato, one of Price's wrestling coaches at PHS, said, "As a student-athlete Job was recognized by his peers and teachers as self-motivated, focused, and disciplined. We enjoyed his sense of humor and willingness to always lend a helping hand . . . Job understood the importance of placing the greater good above self and dedicated his career to helping ensure our freedoms." (Courtesy of the Price Family.)

CHAPTER EIGHT

Health and Wellness Trailblazers

All communities need a corps of trained professionals to minister to the injured and infirm. The spread of communicable diseases in the early years of Pottstown's existence was a given, especially before the development of antibiotics. Then, as Pottstown's population grew, so did the dangers of manufacturing employment. Life was difficult and dangerous in many ways unimaginable today, and life spans were shorter as a result, but Pottstonians stood a fighting chance.

Pottstown had the benefit of two hospitals in the early 20th century. Fundraising for Pottstown Hospital, located on North Charlotte Street, was begun by the newly formed King's Daughters Association in 1888 "to provide a hospital for the immediate care of persons suffering from recent bodily injury and acute diseases." The hospital opened in 1892 and underwent many expansions during the first half of the 20th century, culminating in a modern addition in the 1950s. The second hospital, Memorial Hospital, opened in 1914 in the home of Dr. W.H. Eck in the east end on High Street. It, too, expanded during the 20th century.

During those initial years, the nurses on duty came from Reading Hospital, so in February 1894, the Pottstown Hospital School of Nursing was opened. It is this program that taught one of the most accomplished nurses to ever practice: Hildegard Peplau. She was born in Reading in 1909 and saw up close the ravages of the 1918 flu epidemic. She was also a strong-willed woman who saw that nursing might be her ticket out of an oppressive household. She graduated from the Pottstown Hospital School of Nursing in 1931 at a time when nurse training was becoming more field-based and under the care of teaching hospitals, and Pottstown's medical community was doing the same.

It is in this setting that practitioners like Dr. J. Elmer Porter, Dr. Alice Sheppard, and the four generations of Van Buskirks served the people of Pottstown for decades, setting the gold standard for those who came after them, both in medicine and in all-around good citizenship. Of course, there are thousands of doctors, nurses, psychologists, chiropractors, physician's assistants, radiologists, and countless other support people who have committed themselves to the well-being of the community throughout the centuries. They have all taken it upon themselves to alleviate others' suffering.

More recently, especially in the years following the merger of the two hospitals to create the Pottstown Memorial Medical Center at High Street and Armand Hammer Boulevard, society's notion of health has expanded to include preventive measures to ensure a longer, disease-free life. This era of ever more sophisticated means to help maintain optimal health is also one in which reducing stress and living more simply are recognized as beneficial not only to humans but to the planet. This approach encompasses growing and eating local, organic food; spending more time being active out of doors; conserving natural resources; and giving objects another life through recycling to keep the air and waterways clean.

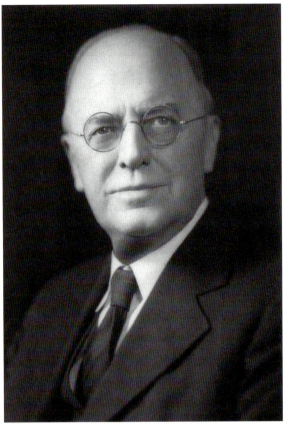

Doc Porter
In 1867, at two years of age, J. Elmer Porter was afflicted by infantile paralysis. Although it would cause him to limp slightly for the rest of his life, it led his father to keep him busy reading. He graduated from Pottstown High, received his medical degree from Jefferson Medical College in Philadelphia, and began practicing medicine at 232 High Street in 1887. He practiced in Pottstown for 64 years and was a savvy businessman and benefactor. (Courtesy of Pottstown Historical Society.)

Legacy of Generosity
Martha Deborah Porter (left) and Mary Newborn Porter were the daughters of Dr. J. Elmer Porter, born 12 years apart to different mothers. Martha's mother, the former Ada Kehl, died in 1902, and Doc Porter married Annilla Newborn in 1904. Both sisters were noted philanthropists. Neither one married. Martha lived in the family home at 344 East High Street until her death in 1983; Mary lived out her later years in Florida. (Courtesy of Pottstown Historical Society.)

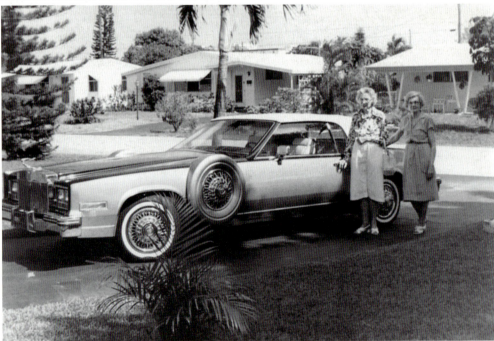

CHAPTER EIGHT: HEALTH AND WELLNESS TRAILBLAZERS

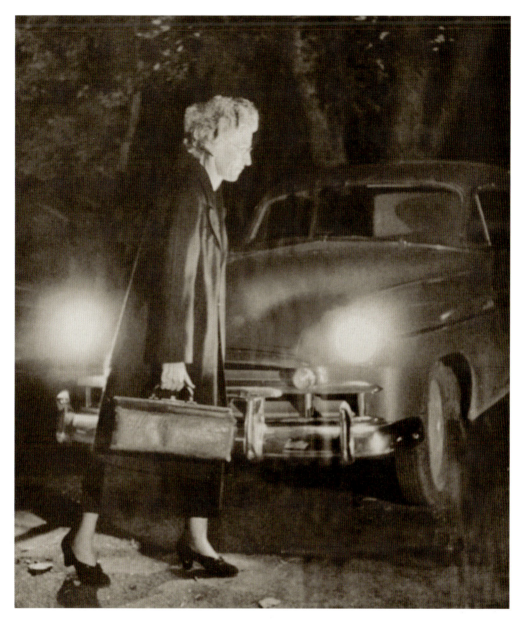

Woman Doctor
According to a 1949 *Look* magazine article that would give her a taste of fame, Dr. Alice E. Sheppard had delivered 1,250 babies up to that time. Born in 1898 at 722 King Street, she grew up to attend Mount Holyoke College for women in Massachusetts, graduating in 1919. After a brief teaching stint at Wyndcroft, she went to New York City to work in a lab at Columbia for a couple of years in preparation for medical school. She went to the Women's Medical College of Pennsylvania, now Drexel University's College of Medicine. After further training, she came home again and opened her first office at 14 North Franklin Street. The December 20, 1949 *Look* article titled "Woman Doctor" featured photographs of her by John Vachon, a *Look* photographer of some renown who had worked for the Farm Security Administration capturing the rural poor on film during the late 1930s. (Photograph by John Vachon, *Look* Magazine Photograph Collection, Library of Congress; courtesy of Ann Vachon.)

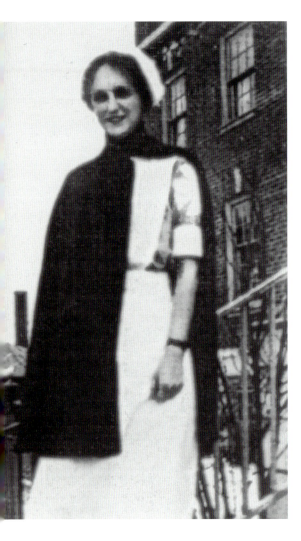

Revolutionary Nursing Theorist

Hildegard Peplau received her nursing diploma from the Pottstown Hospital School of Nursing in 1931 and revolutionized care for those with personality and behavioral disorders with her theory of interpersonal nursing. Known as the "mother of psychiatric nursing," she developed and advanced the idea of a truly therapeutic patient-nurse relationship. While working as a nurse at Bennington College, she got her degree in interpersonal psychology in 1943. From there, she received advanced degrees from Columbia University's Teachers College. Her publication of *Interpersonal Relations in Nursing* in 1952 was unusual because it did not have a male doctor as coauthor. Peplau was on the faculty of the College of Nursing at Rutgers University from 1954 to 1974. She died in 1999 after living through a century of rapid growth in the field of nursing, herself in the midst of the sea change. (Both, courtesy of the American Nurses Association.)

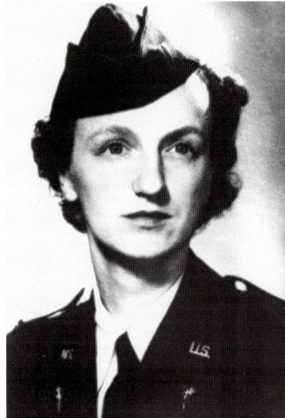

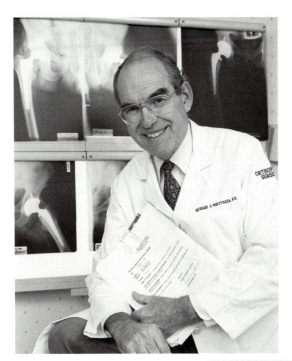

A Walking and Cycling Advertisement
For 38 years, Dr. Richard P. Whittaker was an orthopedic surgeon in Pottstown who entered the burgeoning field of total joint replacements. "Like anything else that's new, it took some selling. It wasn't for everybody," he said. "You had to be adventuresome." The beneficiary of two hip replacements himself, he has set a goal of riding 3,000 miles in charity events to raise awareness and funds for the Brandywine Creek Greenway in southeastern Pennsylvania. (Courtesy of Pottstown Memorial Medical Center.)

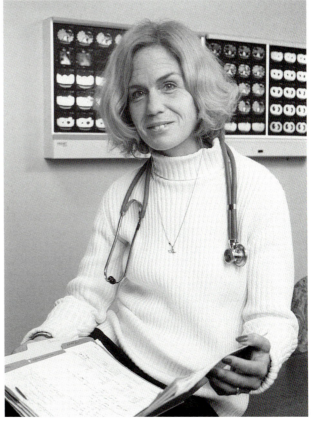

Making the Most of Each Day
In high school, Peggy Neese worked in a nursing home and noticed how cancer patients appreciated life. They inspired her to make the most of each day. She was the first nurse in the oncology department at Pottstown Memorial Medical Center in 1979. Now, she is director of Oncology Services. She was instrumental in starting Pottstown Relay for Life, which is the fifth-most successful Relay team in the world. (Courtesy of Pottstown Memorial Medical Center.)

Rollin' on the River

The Schuylkill River National & State Heritage Area (SRHA) promotes conservation, education, recreation, historical preservation, and tourism in the five southeastern Pennsylvania counties it passes through. It is headquartered at 140 College Drive in a former electric company substation that is being jointly restored with Montgomery County Community College, the building's owner. Executive director Kurt D. Zwikl (top) came on in 2003 to implement a management plan that included building the 130-mile Schuylkill River Trail in partnership with other organizations and expanding the Schuylkill River Sojourn, the organization's signature weeklong, 112-mile guided paddle from rural Schuylkill Haven to Boathouse Row in Philadelphia. Zwikl brought political, banking, and economic-development experience to the job, including a stint representing Allentown in the state legislature from 1973 to 1984. The SRHA has had Sojourn participants from 20 states; Washington, DC; and two provinces of Canada. "People are looking for these adventures, and somehow they've found us," he said. (Above, photograph by Ed Berger; below, photograph by Kim Weber, courtesy of SRHA.)

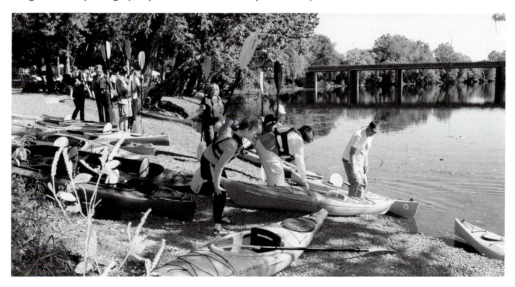

Healthy Living Through Healthy Lifestyles

With a background in foundation management and a childhood influenced by his parents' civic involvement and religious commitment, Dave Kraybill has found a home at the Pottstown Area Health & Wellness Foundation. As executive director for the past eight years, Kraybill has focused the foundation's efforts on nutrition and physical activity in schools, access to primary and behavioral health services, nonprofit-infrastructure development, and recreation and planning for communities.

After skipping his senior year of high school in the Altoona area to do mission work with the Presbyterian church in a secondary school in Utah, Kraybill went on to major in economics at Carnegie Mellon. While there, he found himself organizing other students in a faith-based effort to work at the Jubilee soup kitchen and at a women's shelter in downtown Pittsburgh. "When you think about it," he says, "Faith groups were the ones providing social services during the 19th and early 20th centuries."

Following a career in banking and fundraising, Kraybill landed at the foundation, which was established as the result of the 2003 sale of Pottstown Memorial Medical Center (PMMC) to Community Health Systems. PMMC had been formed back in 1970 in a merger of Memorial Hospital (formerly Homeopathic Hospital) and Pottstown Hospital. By the turn of the 21st century, however, the board of directors made the difficult decision to sell to a fiscally stronger health care entity. In the end, it was right for the hospital and the newly formed foundation, which had net assets of $79 million as of April 2012. The foundation is a nonprofit organization that serves residents of Pottstown and those within a 10-mile radius of the borough. It provides grants to nonprofits and schools, which use the money to support the foundation's purpose.

"Healthy living is our long-term goal," says Kraybill. "And that the Pottstown region becomes one of the healthiest regions in Pennsylvania. Smoking cessation started 40 years ago. Look how far that has come. We're looking at the same continuum. How can we create healthy habits that last a lifetime? How can we work together as a region to achieve some of those goals?" (Courtesy of Dave Kraybill.)

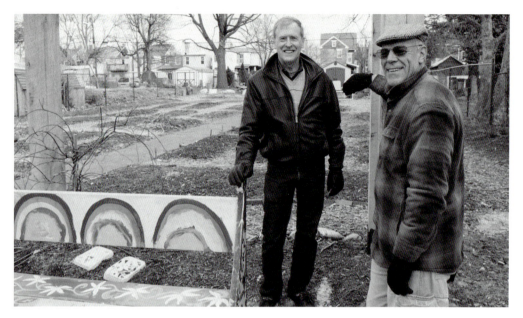

How Does Their Garden Grow?
Pottstown's first community garden sprang up at 423 Chestnut Street in 2012 in the heart of MOSAIC Community Land Trust's neighborhood-revitalization target area. Dave Garner (left), a local attorney and lifelong resident, and David Jackson, a former United Airlines pilot, founded the nonprofit in 2010 along with Chris Huff and author Sue Repko. The arbor was designed by Pottstown custom-furniture maker Ryan Procsal. Another garden at 615 Chestnut Street is in the works. (Photograph by Ed Berger.)

Earth Day Everyday
Jim Crater was in the ecology club at Owen J. Roberts High School in 1971 when the genesis of Recycling Services, located across the river at 365 Elm Street, took root the year after the first Earth Day. "I'm a gardener," he says. "I plant ideas. Lots of them. They become fertile ground for new ideas." The peacock, Mr. Peabody, has been living on site for eight or nine years. (Photograph by Ed Berger.)

CHAPTER NINE

Community Builders

The people of Pottstown have a history of civic pride, compassion for others, willingness to serve, respect for traditions, and an enjoyment of the company of other citizens and friends. This chapter highlights just some of the many community organizations and individuals who have contributed, or are contributing, to the life of the town in just these ways.

With the coming of the railroad in 1842, the iron and steel industries expanded, providing greater employment across all sectors of manufacturing and making Pottstown a popular destination for immigrants and those already in the region who were looking for work. As Pottstown's population steadily grew throughout the latter half of the 19th century and the early 20th century, all sorts of civic and community organizations took root as well. After a long shift on the job, or a long week of shifts, people needed the respite and camaraderie of belonging to a civic or social club. Some of these groups were linked to churches, while others were open to the broader community.

Many of the people depicted in this chapter have been part of organizations that are national or international in scope, such as the YWCA, YMCA, and the Elks. Others, like Margaret Banks, George Wausnock, and Bill and Sue Krause, took initiative on their own: they saw needs in the community and set about filling them over many, many years. They have stood the test of time, and yet there are countless people in Pottstown who are helping others in myriad ways. Some are literally saving lives. Others are sharing their heritage with the larger community, or advocating for those who have not yet found their voice, or doing what is right simply because it is the right thing to do.

This chapter highlights and salutes the contributions of just a few of Pottstown's community builders. On their own, or as part of an organization, they have provided the social foundation of the town from its earliest days, and they are everywhere today—good people doing good work.

Members Make the YMCA

For many who grew up in Pottstown, the YMCA is where they learned to swim and play basketball, went to camp, or attended child-care programs. At its first organizational meeting in 1880 in the Landis and Snell building at 233 High Street, the YMCA had 25 members. In 2013, there were more than 3,500 members using the facilities at the corner of Adams and Jackson Streets. Over the years, tens of thousands have experienced the benefits of "putting Christian principles into practice through programs that build healthy spirit, mind, and body for all." Today, the Y's programs promote strong families, fitness and wellness, child and adult development, and equality for all. Since 1999, the Pottstown YMCA has instructed nearly 3,500 third graders in the Pottstown School District in a no-charge learn-to-swim program. (Above, courtesy of Hannah Davis; below, courtesy of Pottstown YMCA.)

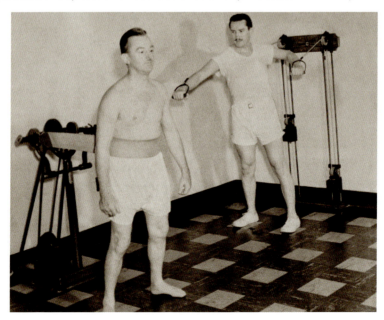

It Takes a Village

Those who remember Sally Lee speak her name today in an almost reverent tone. Lee earned the admiration of all who came into her orbit over the course of 19 years at the YWCA Tri-County Area in Pottstown. She joined the YWCA in 1980 as a founding member of the Parents' Support Group, serving as program director and marketing director before becoming the executive director in 1987. Between then and 1999, she helped create the Black Heritage Celebration; EXCELL, a support group for professional women; the Week Without Violence; and the annual Tribute Dinner for Exceptional Women. The photograph below shows a young women's basketball team from Second Baptist Church in 1938. African American women were welcomed to physical education programs at the Pottstown YWCA, which also hosted racially integrated dances in the 1940s. (Right, courtesy of the Lee Family; below, courtesy of the YWCA Tri-County Area.)

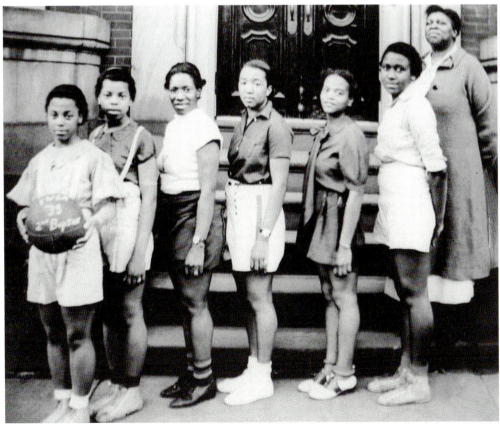

Pottstown Area Seniors' Center
Not only are people living longer, they are also working longer and taking steps to remain physically and mentally active. Since its founding in 1976 by Rev. Will Penny of Christ Episcopal Church, the Pottstown Area Seniors' Center (PASC) has been a place for members to "create, maintain, and sustain" through social and physical activity. A hot lunch is served each weekday. PASC moved to its current location at the YMCA in 1998 and is currently fundraising and renovating a 20,000-square-foot building at 288 Moser Road to serve as its future home. Shown above are long-term board members and key staff, from left to right, (first row) Deborah Dollar-Reid, Lillie Foster, and Mary Ann Lawrence; (second row) assistant executive director Bob Hager, executive director Bradley Fuller, and Dr. Garland Fisher. Below, Sophie Voynar (right), now 107 years old, is shown with Helen Neiffer. (Above, photograph by Ed Berger; below, courtesy of PASC.)

CHAPTER NINE: COMMUNITY BUILDERS

Past Exalted Ruler

When Earl Decker started getting serious with Mary Anne Lessig, she said, "If you're going to marry me, you have to join the Elks." She had grown up around the Benevolent and Protective Order of the Elks Lodge No. 814 at 61 East High Street, where her father, Spencer Lessig, was a member for 61 years and a past Exalted Ruler. Once Decker joined in 1967, he made his own mark, serving for years on the charity ball, ritual, scholarship, and various state-level committees. He was Exalted Ruler from 1975 to 1976 and Elk of the Year in 1982. He attended every national convention from 1975 to 1995. "I have friends throughout the country who I never would have met if not for the Elks," he said. The Lodge had three national championship drill teams in 1938, 1941, and 1952. Spencer Lessig is eighth from the left in this 1938 image. (Left, photograph by Ed Berger; below, courtesy of Earl Decker.)

The Slovak American Women's Guild
The Slovak American Women's Guild is rooted in a tradition of Catholic values and Slovak culture. Their work reaches out in love to the needy while also preserving and promoting the South End's rich eastern European cultural heritage. The women bake nut rolls every November, agonizing over the quality of the final product. It is truly a labor of love. Shown here are, from left to right, Mary Jane Hegedus, Sylvia Landis, and Rita Ferraro. (Courtesy of Bonnie Stankunas.)

South End Reunion President
For more than 20 years, Gerald Kerr (right) was president of the South End Reunion, and Dominic Viscardi was the vice president for this annual gathering of a couple hundred South End residents who had grown up together during World War II. Olga High first hosted the event at her farm. It then moved to Towpath Park, and it is now held the Sunday after Labor Day at Ringing Rocks Park. Kerr passed away in April 2013. (Photograph by Don Hegedus.)

CHAPTER NINE: COMMUNITY BUILDERS

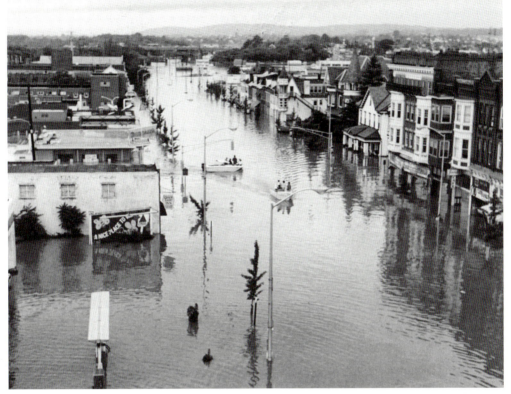

Hurricane Agnes
She is a legendary local because she pounded Pennsylvania the hardest in her rampage up the east coast. Agnes arrived in Pottstown on June 22, 1972. When she left, the downtown, adjacent neighborhoods, and industrial area were completely flooded. President Nixon declared the Schuylkill River valley a disaster area. Here, boats chug down the 100 block of High Street. This shot was taken from the roof of the Shuler Hotel. (Photograph by Dominic Viscardi.)

The Beat of a Different Drummer
Mary Pennypacker and her tattered petticoats are legendary. In the 1960s and 1970s, Pennypacker, right, went everywhere with her dog in a baby carriage, and they often shared an ice-cream cone on the steps of the old post office. Dominic Viscardi (left) recalls Pennypacker coming up behind diners at the counter of the Shuler Hotel and asking, "Are you gonna finish your toast?" Pottstonians showed compassion toward the eccentric Pennypacker, who was not homeless and lived in the South End. It was rumored that she stashed her cash under her mattress. (Courtesy of Dominic Viscardi.)

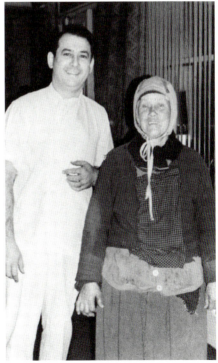

Walking the Walk
Since 1999, internationally certified personal trainer Paul Winterbottom has been inspiring Pottstown residents between the ages of seven and one hundred through his fitness boot camps at the Richard J. Ricketts Center at 640 Beech Street. He also offers personal training at Gateway Counseling Services through their Healthy Step program. In 2007, Winterbottom was recognized by the US military for training area recruits for the military physical. (Photograph by Ed Berger.)

From Corporate to Community
Jan Burgess had a career in the corporate world, but when the opportunity came along to work with youth in her neighborhood, the Pottstown native took it. A position with the Olivet Boys and Girls Club 21st Century program at the Pottstown Middle School led to her current position as unit director at the Richard J. Ricketts Center, where she has been since 2007. (Photograph by Ed Berger.)

CHAPTER NINE: COMMUNITY BUILDERS

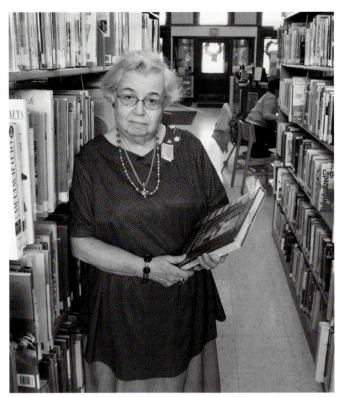

Dewey Decimal Professional
Clara Hoss, who has worked at the Pottstown Public Library for more than 52 years, was recognized by borough council in April 2010 for her half-century of service. She started volunteering while in high school and, when given a chance at a paid position, she took it. While Hoss is computer literate, she is also an expert in the Dewey Decimal System and enjoys stumping the other librarians. (Photograph by Ed Berger.)

Neither Snow nor Rain nor Heat Could Stop Her
Although Pat Rhoads was born in Pottstown, her father was career military, and she was raised all over the world. Perhaps all that travel gave her the will to stay put. She is shown here on her last day after 40 years with the US Postal Service. A tenor in the Coventry Singers, Rhoads has found that retirement brings more time for Senior Follies, reading, cooking Japanese food, and hand beading Christmas balls. (Photograph by Ed Berger.)

Mr. and Mrs. Pottstown

Bill and Sue Krause have just about done it all for Pottstown. For more than 60 years, one or the other has been volunteering, dreaming up, enlisting support for, and carrying out innumerable community events and fundraisers.

Sue and Bill were founding members of the Historic Pottstown Neighborhood Association around 30 years ago. A historic house tour in December became Sue's special project. Hundreds purchase tickets and come out on a Sunday afternoon in December to view beautifully decorated homes that reflect the best of Pottstown's architectural past. "Several couples came back and bought houses in Pottstown after going on the tour; that's been one of many positives," said Sue. She has also run Pennies for Penney's, Pottstown's Flag Contest, and most recently participated in Wreaths Across America in 2012.

In addition to his volunteerism for the Phillies Fire Company, which he began at age 15 in 1950, Bill is a long-term board member of the Pottstown Historical Society and Pottstown Area Seniors' Center. He has been attending borough council meetings since 1961, and he served on council from 1985 to 1991, representing the fourth ward. He has also been the master of ceremonies for the annual New Year's Day events at Riverfront Park since 2000 and was a radio host of "Moments to Remember" on WPAZ from 2005 to 2008. Both he and Sue arranged with the Antique Automobile Club of America to have the 50th anniversary Glidden Tour come through Pottstown in 1995. And they have been volunteers at Sunnybrook for the past four years.

So, how did this dynamic duo meet? Sue worked at the Donut Fair on High Street, and Bill stopped in when he was home on leave from the Army in January 1961. "Those were the sweetest donuts I ever had," recalled Bill with a smile. They were married on September 19, 1964.

Evidently, the sweetness lingered through the decades as they teamed up to run an ice-cream festival in 2002 as part of the 250th anniversary of Pottstown's founding. On the lawn between Zion's United Church of Christ and Emmanuel Lutheran Church, kids could run on a treadmill which helped to churn ice cream. It was $1 for all you could eat and 25¢ for all the toppings. High school choruses sang throughout the day, the weather was perfect, and they ran out of shoofly pies, the true mark of a successful event. (Photograph by Ed Berger.)

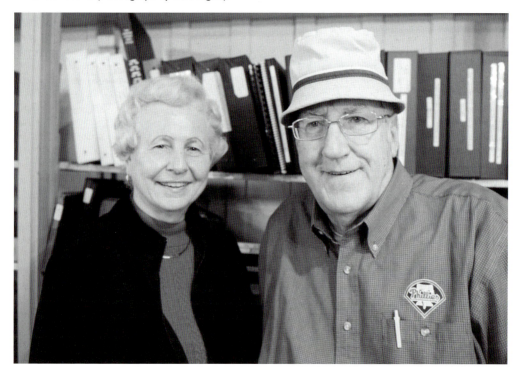

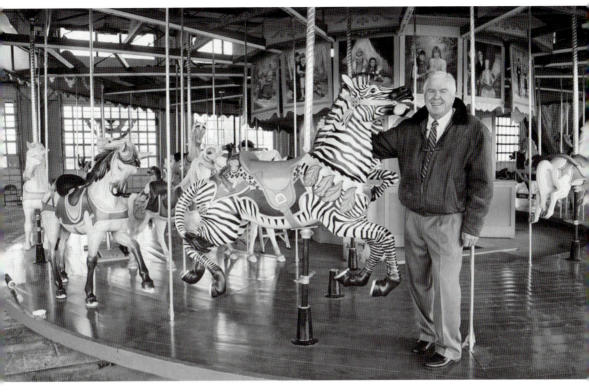

Preserving the Past, Creating the Future

A core group of residents and business leaders are committed to the idea that the borough's future lies in its past, and George Wausnock is one such person. In 1999, during his tenure as president of the Pottstown Historical Society, the group bought the mechanism of a 1905 Philadelphia Toboggan Company carousel for about $19,000. First, though, they did their homework. Specifically, they saw the potential for an old-fashioned carousel to draw visitors and families back to Pottstown after learning about similar projects in Mansfield, Ohio, and Holyoke, Massachusetts. That same year, they received a $100,000 donation from Mark and Donna Saylor to honor their son Derek, who had died in 1997. The group was on its way, formally incorporating as the Carousel at Pottstown in 2000. Relying on the talent and hard work of volunteers, the Carousel has steadily reconstructed the carousel structure, commissioned the animals, and found a home at 16 West King Street in the old Metal Weld building. "It's always the people in the organization who make things happen," notes Wausnock. "Not just me." The Carousel of Flavor, an annual fundraiser and food festival, now draws thousands downtown on a Sunday afternoon in September to sample food from area restaurants and caterers.

Wausnock was a cofounder of the Carousel (along with Ronald C. Downie) and has been president for about seven years. He was also the president of the former Old Pottstown Preservation Society. Born in the old Homeopathic Hospital on East High Street and raised in Pottstown, his first job was as a salesman for Alpo dog food, trying to get more shelf space for the product in area stores. At the age of 25, he was one of the oldest draftees to leave Pottstown, serving in the Army from 1963 to 1965. He met his future wife, Joan, while in the service, and they were married in 1966.

In 1970, he began working for the company with which he would spend the next 42 years—State Farm Insurance. After having his office in the North End for many years, in 1989, he purchased and began restoration of the Grubb mansion at 1304 East High Street, just a stone's throw from where he had been born. The building is now in the National Register of Historic Places. Wausnock's efforts to preserve and celebrate Pottstown's heritage are in evidence from one end of town to the other. (Photograph by Ed Berger.)

It's All in the Details

Long before the world became more accommodating to the needs of folks of varying abilities, Bob Roebuck was charting his own course. Legally blind from birth, Roebuck lived in Lafayette Hills, Pennsylvania, on the estate of George D. Widener Jr. (also known as Erdenheim Farm), where his father was a butler. He attended Overbrook School for the Blind in Philadelphia and graduated from Wilkes College in 1966. At that time, there were only two master's degree programs in the country for teaching rehabilitation, orientation, and mobility to the adult blind, and Roebuck got his master's degree from Western Michigan University in December 1967. Following a very challenging six-month field placement in New York City, he returned to southeastern Pennsylvania, living in Pottstown and landing a job at Pennhurst.

In his work, Roebuck trained legally blind and visually impaired, mentally challenged individuals for reentry into the world outside of Pennhurst. After 15 years, as Pennhurst was closing, he qualified to become a caseworker at Norristown State Hospital, where he remained until his retirement in 2003. In 1979, he received the "State Handicapped Employee of the Year" award from Governor Thornburgh in Harrisburg.

But Roebuck's contributions to the Pottstown community extend far beyond his career. He is a long-term board member of the Pottstown Area Seniors' Center, where he participates in the As Time Goes By Singers, the History Club, and the Lunch Bunch. For the past quarter-century, he has been a singer with the Ches-Mont Jubilaires, an all-male a cappella group and local chapter of the Barbershop Harmony Society. For the past couple of years, he has contributed his creative talents to the Senior Follies at the Steel River Playhouse, and he is also involved in a recreation group for the legally blind and visually impaired at a local church.

Perhaps most extraordinary is the commitment and attention to detail that he has shown for more than nine years. On most Monday nights, he has been in a workshop at 309 East High Street, sanding wooden carousel figures for the Carousel restoration project. Most recently, he has been working on the mythological seahorse Hippocampus, which has the head of a horse, the body of a fish, and the flowing tail of a mermaid. It took 19 months to sand and will take 14 more after the primer coats. It is a painstaking process, but Roebuck has the fortitude required to complete it. (Photograph by Ed Berger.)

CHAPTER NINE: COMMUNITY BUILDERS

Honoring the Past
David Kerns and Clara Hoss are the longtime local volunteer historians at the Pottstown Historical Society. They help visitors find answers about genealogy or historic people, businesses, and buildings. The Pottstown Historical Society undertakes the acquisition and preservation of Pottstown artifacts and historical resources and is located at 568 East High Street in an 1884 structure built by Lloyd Keim. (Photograph by Sue Repko.)

Teller of Historic Tales
Since 2001, Michael T. Snyder has been writing a monthly feature for the *Mercury*—"First Sunday, Look at History"—which takes readers on a journey through some aspect of Pottstown's past. When doing local research, he finds that one thing usually leads to another. In 2010, he published *Remembering Pottstown: Historic Tales From A Pennsylvania Borough*. Snyder is in his second term as president of the Pottstown Historical Society. (Photograph by John Strickler.)

119

The Spirit of Service
Margaret Banks touched the lives of countless young children in Pottstown through her volunteerism in the public schools and the Montgomery County Foster Grandparent Program. It was her outstanding work as a foster grandparent and a recruiter of other senior citizens for the program that resulted in her receiving the "Spirit of Service Award" from Pres. George W. Bush in 2004, when she was 74 years old. She traveled to Kansas City, Missouri, to receive the award. She was the only foster grandparent nationwide to win this honor.

Her other volunteer activities included the Head Start program, Town Watch, Families and Schools Together (FAST), Girl Scouts, Ricketts Community Center, Genesis Housing Corporation, and working the polls during elections. In 1998, Banks received the Joyce Reddick Award from the YWCA Tri-County Area during its Black Heritage Celebration. (Photograph by Ed Berger.)

CHAPTER NINE: COMMUNITY BUILDERS

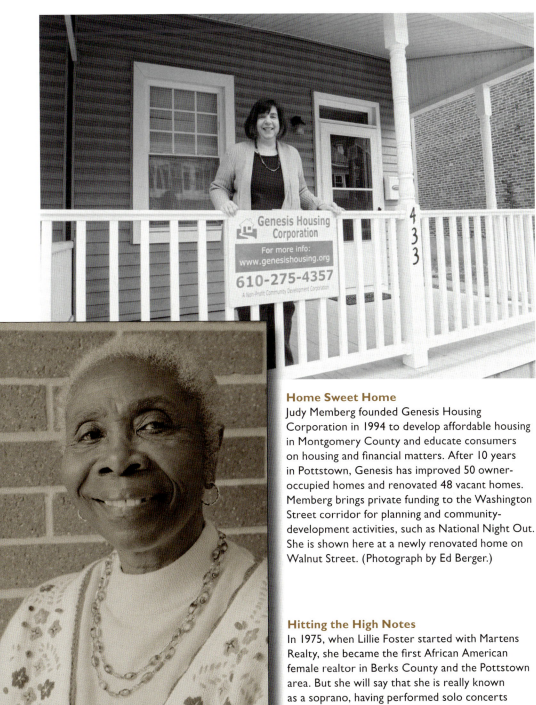

Home Sweet Home
Judy Memberg founded Genesis Housing Corporation in 1994 to develop affordable housing in Montgomery County and educate consumers on housing and financial matters. After 10 years in Pottstown, Genesis has improved 50 owner-occupied homes and renovated 48 vacant homes. Memberg brings private funding to the Washington Street corridor for planning and community-development activities, such as National Night Out. She is shown here at a newly renovated home on Walnut Street. (Photograph by Ed Berger.)

Hitting the High Notes
In 1975, when Lillie Foster started with Martens Realty, she became the first African American female realtor in Berks County and the Pottstown area. But she will say that she is really known as a soprano, having performed solo concerts throughout the region over a 50-year span, including 10 years with the Coventry Singers. She has been a toastmaster since 1982 and is an active board member of the Pottstown Area Seniors' Center. (Photograph by Ed Berger.)

LEGENDARY LOCALS

Volunteer Street Sweeper

No one asked him to do it, but Richard Hogey—known simply as "Hogey"—has been cleaning the streets of Pottstown, in his own brand of community service, for the past seven years. His territory is bounded by Hanover, Beech, Adams, and High Streets. "If you keep after something, it doesn't get so bad and it doesn't take so long to clean up," he said. Here he is at age 72. (Photograph by Ed Berger.)

"I Just Did My Job"

From 1960 to 2012, Bob Hartman Sr. laid out curbs and sidewalks, wrote specs, did cost estimating, inspected roads and sewers, and dealt with the public—whatever the public works department asked him to do—making him the longest-serving employee for the Borough of Pottstown. "In the borough, the product is service to the people. No two days are the same. I could never have worked in a factory." (Photograph by Ed Berger.)

CHAPTER NINE: COMMUNITY BUILDERS

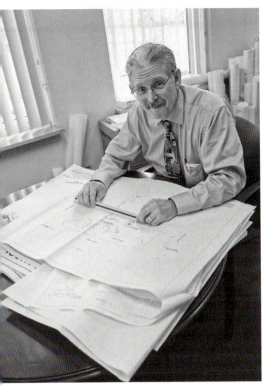

Behind the Scenes
Doug Yerger started out as an electrician with the borough in 1974 and went on to the title of borough electrician in 1977. Then, in 1989, he made the leap to public works director. Today, most horizontal surfaces in his office are covered with the drawings that help keep people safe. "We manage everything from traffic lights to underground piping, roads, street signs. All the things people depend on but don't really see," he said. (Photograph by Ed Berger.)

A Consummate Manager
Bob McKinney (far right) was Pottstown borough manager from 1956 to 1965, overseeing the town during its industrial and manufacturing heyday. Afterward, he went to work for Ed Gruber (second from right) as vice president of Spring City Knitting, the largest manufacturer of boys' and men's underwear in the United States. He was president of R.H. McKinney Jr. Associates, consulting engineers, and has owned the New York Plaza building at 238–244 East High Street for nearly two decades. (Courtesy of Bob McKinney.)

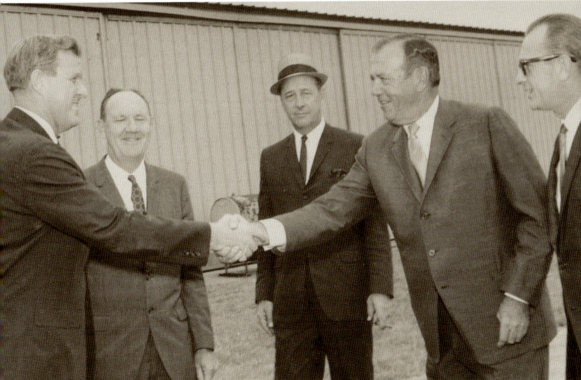

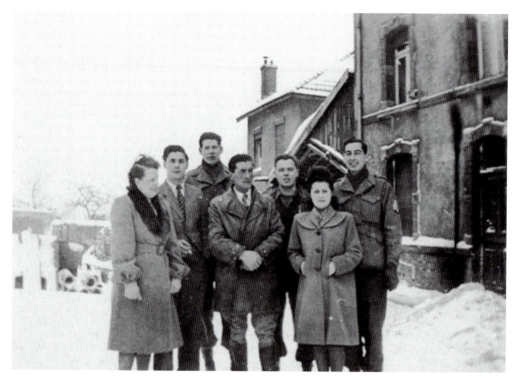

Living to Tell the Tale: The Battle of the Bulge

Willard Bickel served in the Third Army, 26th Infantry Division, 104th Regiment and fought in the Battle of the Bulge. He was born in Pottstown in 1924 and graduated from Pottstown High School in 1941. He likes to note that he said "I do" twice in February 1943—once to his wife, the former Margaret Robenolt, and a second time to Uncle Sam. He then spent 18 months stateside and 18 months overseas, arriving on Omaha Beach just 60 days after the D-Day landings.

Bickel, Gabe Fieni, and Charlie Daniels were instrumental in getting a World War II memorial built in Pottstown. They did a lot of fundraising, and John O'Boyle of J.O.B. Construction was very helpful, donating way more time than he billed the veterans group. The memorial is located near the pavilion in Memorial Park at the intersection of King and Manatawny Streets. In 2012, the Pottstown Joint Veterans Council gave Bickel the "Veteran of the Year" award. Today, at 89, Bickel is a speaker who shares his wartime experiences with audiences throughout the region. One such tale, which Bickel has committed to paper with editing help from his daughter Connie Rohrbach, involves a frightening near-encounter with Nazi soldiers that could easily have taken a fatal turn.

While moving through France, Bickel had some periods of rest and the chance to meet French citizens very thankful for liberation. During one rest period, he and his fellow soldiers had a home-cooked meal with a French family. After the meal and a welcome shower, they were housed overnight on the third floor of the home.

"While we slept," Bickel recalls, "Nazi troops removed all the men from the house below. We were unaware of what was happening. In the wee hours of the morning, the women of the house awakened us to the sad news that their men were gone." The American soldiers could not believe this was happening, until they looked out the window. "Sure enough," says Bickel, "By the light of the full moon and a blanket of snow, we were able to see German soldiers and witness the activity occurring below. Also unbelievably, two German soldiers had United States uniforms, obviously taken from dead soldiers' bodies." They suspected that was how they had been able to break through the American lines. They quickly exited the area and went back to their headquarters. Needless to say—a near miss!" says Bickel, who is shown here (third from right). He is flanked by John Payne and Richard Laver. (Courtesy of Willard Bickel.)

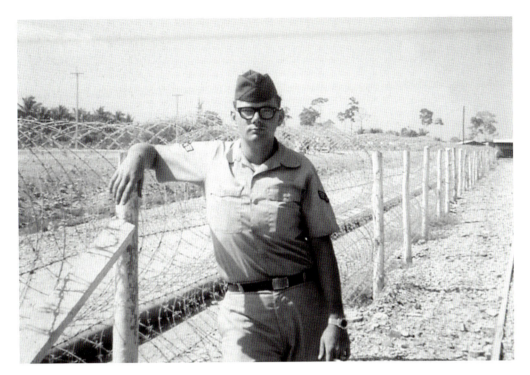

A Living Memorial

Frank Strunk has been the president of the Vietnam Veterans of America Keystone Chapter 565 since 1991, except for one year off to serve as president of the Rotary Club. He was instrumental in helping build the Vietnam Veterans Living Memorial in Pottstown's Memorial Park. From about 1991 until 1996, dedicated veterans and volunteers worked from spring until Veterans Day to complete the project, which has become the focal point for Memorial Day and Veterans Day observances.

"Once we came out of the closet, everyone else did, too," says Strunk. "Stores in town dropped off hoagies and pizzas in the summer. It wasn't an easy task but was surprisingly fruitful. Not that people agreed to the war, but they could say they were sorry for not supporting those who had no choice but to go."

Strunk was drafted in 1964 at the age of 21. Although he was born and raised in Ashland, Pennsylvania, he had been working in the accounting department of United Airlines in Chicago at the time. He ended up in the Strategic Air Command (SAC) headquarters in Omaha, Nebraska. When the B52s moved to Southeast Asia, he went with the combat support group, landing at U-Tapao Airfield in Thailand; this photograph shows Strunk in Thailand. Then they moved to Da Nang, Vietnam, where he was stationed from 1966 to 1967 as an air rescue crew member.

After the war, he went back to the coal region, spent a couple weeks there before realizing there were no job opportunities, and came to live with his sister in Pottstown. He got a job in a financial institution in Reading and went to school part time on the GI Bill.

"Those were the days when you didn't admit you'd been in Vietnam. People came back with different ghosts. But I wasn't on the ground. Ground combat personnel came back with ghosts, but no more than the Second World War or Korea."

On the construction of the memorial, Strunk is adamant: "Not one person could have achieved this job. There was a nucleus of about 12, give or take." Other key personnel in establishing the memorial, dedicated on November 9, 1996, were Charles "Sonny" McIlvee (chairman), Norbert "Mo" Shaffer (vice chairman), Terry Foulke (past president), the late Ed Woodland, Bob Stoudt, Terry Baker, Russ Wade, sculptor and Korean War veteran John Chalk, Brian Moore, and electricians James Harp, Larry Harp, and his son Keenan, in addition to many other volunteers. (Courtesy of Frank Strunk.)

INDEX

Ackerman, Nancy, 82
Acton, Jay, 6
Addison, Lida, 87
Alan, Jane, 6
Allen, Lisa, 6
Altschull, Allan, 30
Andre, A.J., 61
Armato, John, 6, 34, 98
Baker, Terry, 125
Bamford, Steve, 60
Banks, Margaret, 107, 120
Bause, Daniel Jr., 57
Bause, Daniel Sr., 57
Bause, Erin, 83
Bause-Bartra, Amy, 83
Beasley, Aaron, 87
Bechtel, Carroll "Mush" Jr., 89, 97
Bechtel, Frank C., 44
Bell, George, 30
Bickel, Willard, 124
Bieber, Anna Mae, 34
Bolinger, Craig, 81
Boughter, Frank, 78
Boyer, Carl W., 44
Boyer, Stanley, 70
Brandt, Evan, 6, 34
Brantly, N.O., 50
Braunsberg, Dennis, 8
Brendlinger, Dr. Leroy, 40
Brower family, 47
Brumbaugh, G. Edwin, 12, 13
Brunish family, 80
Burgess, Jan, 114
Butler, Heywood L., 26
Calvario, Bob "Chuz", 91
Carr, Sabin, 89
Carter, Gregory R., 48
Carter, Jean, 48
Cavallo, Al, 91
Chalk, John, 125
Chancellor, Paul, 6, 7, 27, 31, 44
Childers, Naomi Weston, 70
Codispoti, Bijal, 68
Codispoti, Faryl, 68
Colbath, Dozie, 13

Conway, Ray, 81
Cook, Kathy Detar, 97
Crater, Jim, 106
Dautrich, Eileen, 60
Davenport, Stanley I., Jr., 35
Davis, Josh, 79
Davis, Ken, 96
Decker, Earl, 111
Decker, Mary Anne Lessig, 111
DiFillipo, Dave, 91
Dollar-Reid, Deborah, 110
Downie, Ronald C., 72, 117
Dugan, Gene, 82
Dugan, Sheila, 47
Ecker, J. Aram, 54
Ecker, Seth, 34, 87
Eurillo, Julie, 66
Falcone, Michael, 85
Feraro, Rita, 112
Fisher, Dr. Garland, 110
Forrest, Dr. Myra, 66
Foster, Dr. Dean, 41
Foster, Lillie, 110, 121
Foulke, Terry, 125
Frantz, P. Richard, 49
Fretz, Edward S., 17
Fuerman, Neil, 76
Fuller, Bradley, 110
Gabel, Henry, 16, 44
Gabel, Jacob, 16, 44
Garner, Dave, 106
Garner, Janet, 52
Garza, Ron, 84
Garza, Stamos, 84
Gaugler, Denise, 86
Geyer, Jane, 87
Gilbert, Elias Y., 17
Glutz, Kathy, 94
Green Jeff, 34
Grey, Al, 4, 62
Grow family, 76
Gruber, Ed, 91, 123
Haring, Jarred, 54
Harp family, 125
Harris, Charles, 55
Hatfield family, 48

Hartman, Bob, Sr., 122
Hausman, Donna, 79
Hegedus, Mary Jane, 112
Hennessey, Donna, 33
Hiester, William M., 58
Higgins, Linda, 20
High, Olga, 112
Hill, Shandy, 58
Hogey, Richard, 122
Hoover, Joe, 66
Hornburg-Cooper, Erika, 69
Hoss, Clara, 6, 115, 119
Hurricane Agnes, 44, 113
Hylton, Tom, 59
Iezzi, Carolyn, 81
Iezzi, Jim, 81
Jackson, David, 106
Janssen, Charlotta, 69
Jeffries, Louis, 6
Jones, J. Paul, 8
Jones, Lovey, 92
Katch, John, 6
Keim, Lloyd, 119
Kent, Stephen, 74
Kerns, David, 6, 119
Kerr, Gerald, 112
Kiesling, Marta Rubin, 71
Kiss family, 51
Klein, Mike, 78
Kline, J.J., 21
Koffs, George, 57
Krause, Bill, 4, 107, 116
Krause, Sue, 4, 107, 116
Kraybill, Dave, 105
Krouse, Luther A., 22
Kurtz, Eleanor, 27
Kurtz, Emilie, 52
Lachman, Isaac S., 61
Lamb, Margaretta Reid, 64, 65
Lamb, William F., Jr., 64, 65
Lamb, William F., Sr., 4, 63
Landis, Carol, 52
Landis, Carl, 59
Landis, Sylvia, 112
Lawrence, Mary Ann, 110
LeBoutillier, Elise, 79

Lee, Sally, 109
Lees, Mary Ellen, 77
Lessig, Spencer, 111
Lester, W. Carter, Jr., 29
Lindemuth, William H., 21
Longeway, Chris, 4, 83
Ludwick, Dick, 59
Ludy, Bill, 55
Ludy, Stacy, 68
Mankes, Jeremy, 79
March, Nancy, 6
Markofski, Cheryl, 66
Markofski, Henry, 53
Marsh, Marvin, 25
McFadden, Carol Glutz, 94
McFadyen, Elaine, 6
McIntosh, Quiana, 87
McIver, Charles "Sonny," 125
McKinney, Bob, 123
Meigs, George, 37
Meigs, John, 29, 36, 37
Meigs, Marion Butler, 37, 38
Meigs, Matthew, 29, 31, 36, 37
Melis, Jadwiga, 32
Memberg, Judy, 121
Mich, Jim, 93
Michener, James, 38
Miller, Joe, 78
Moore, Brian, 125
Moscia, Ben, 79
Mosteller, Rose, 79
Moyer, Amandus D., 56
Moyer family, 56
Neese, Peggy, 103
Neiffer, Helen, 110
Neiman, Mark, 82
Newman, Darlene, 95
Newman, June, 6
Nixon, Stephanie "Peachie", 95
Nutt, Samuel, 10
Nyman, Lucy, 57
O'Boyle, John, 49, 124
O'Boyle, Pam, 49
Oliver, Gina, 96
Paretti, Cathy, 69
Pennypacker, Mary, 8, 113
Peplau, Hildegard, 4, 99, 102
Pidcock-Lester, Karen, 29
Pollock, Elmer "Chump", 93
Porter, Dr. J. Elmer, 29, 99, 100
Porter, Martha Deborah, 100
Porter, Mary Newborn, 100

Potts, David, Jr., 16
Potts, Henry, 16
Potts, John, 7, 9, 10, 13
Potts, John, Jr., 4, 11
Potts, Dr. Jonathan, 10
Potts, Leonard Harlan, 13
Potts, Ruth Savage, 10
Potts, Samuel, 10
Potts, Thomas, 10
Powell, Doris, 46
Powell, Frank, 27
Price, Job, 98
Prince, Janet Bressler, 6
Ralston, Lauren, 84
Ranieri, Rich, 46
Raski, Frank, 86
Reidenouer, Dave, 6, 92
Reifke, Kathleen, 79
Repko, Patricia, 6
Repko, Richard, 6, 27
Rhame, Sam, 4, 83
Rhoads, Pat, 115
Ricketts, David, 4, 90
Ricketts, Richard J., Jr., 4, 90
Ricketts, Richard J., Sr., 90
Rieger, Louis, 67
Roebuck, Bob, 118
Ross, Vernon, 23
Royer, Galen, Jr., 68
Rutter, Thomas, 10
Salanek Patricia Nester, 35
Saunders, Betty, 13
Saylor, Charles, 44
Saylor Derek, 117
Saylor, Donna, 117
Saylor, Henry "Hank", 44
Saylor, Mark, 117
Saylor, Catherine Bechtel, 44
Schock, Jean, 4, 50
Schorsch, Dr. Emil, 24
Schorsch, Dr. Ismar, 24
Searles, Thomas, 27
Seely, Dan, 92
Shaffer, Norbert "Mo," 125
Shantz, Bobby, 88
Shawell, Sr. Alberta, 6
Sheppard, Dr. Alice, 99, 101
Shuster, Amy, 78
Smith, Amanda, 74
Smith, Robert, 74
Snyder, Michael T., 6, 119
Somiesky, Richard, 61

Sotter Brothers, 14, 15
Sparagana, Dr. Jeffrey, 35
St. Clair, Maj. Gen. Arthur, 11
Stetz, Bill, 91
Stimson-Snow, Deborah, 71
Stoudt, Bob, 125
Stout, Dr. Karen, 4, 42
Stratis, Many, 84
Stratis, Stavros, 84
Stratis-Garza, Jeanne, 84
Strawther, Willis, 26, 39
Strickler, John, 6, 58, 92
Strom, Earl "Yogi", 87
Strunk, Frank, 125
Swann, Sandy, 6
Sweitzer, Dr. Edward, 40
Taylor, Thomas, 61
Trump family, 58
Tschantre, Barb, 6
Vachon, John, 101
Viscardi, Dominic, 6, 8, 77, 112, 113
Vosgien, Erin, 6, 7
Voynar, Sophie, 110
Wachter, William A., 28
Wade, Russ, 125
Wallace, Rian, 87
Walsh, Blair, 85
Walsh, Dave, 85
Wausnock, George, 107, 117
Wausnock, Joan, 117
Weaver, George "Buck", 88
Weitzenkorn family, 4, 45
Wendell, Marjorie Potts, 13
Whittaker, Dr. Richard P., 103
Winterbottom, Paul, 114
Wolf family, 53
Woodland, Ed, 125
Woodling, Tonda, 85
Work, William R., 31
Xander, Rev. Paul J., 6
Yerger, Doug, 123
Zahora, Judy, 33
Zwikl, Kurt D., 104

AN IMPRINT OF ARCADIA PUBLISHING

Find more books like this at
www.legendarylocals.com

Discover more local and regional history books at
www.arcadiapublishing.com

Consistent with our mission to preserve history on a local level, this book was printed in South Carolina on American-made paper and manufactured entirely in the United States. Products carrying the accredited Forest Stewardship Council (FSC) label are printed on 100 percent FSC-certified paper.